Herta Lepie · Georg Minkenberg †

The Cathedral Treasury
of Aachen

Translation by Manjula Dias Hargarter, Ph. D.

SCHNELL + STEINER

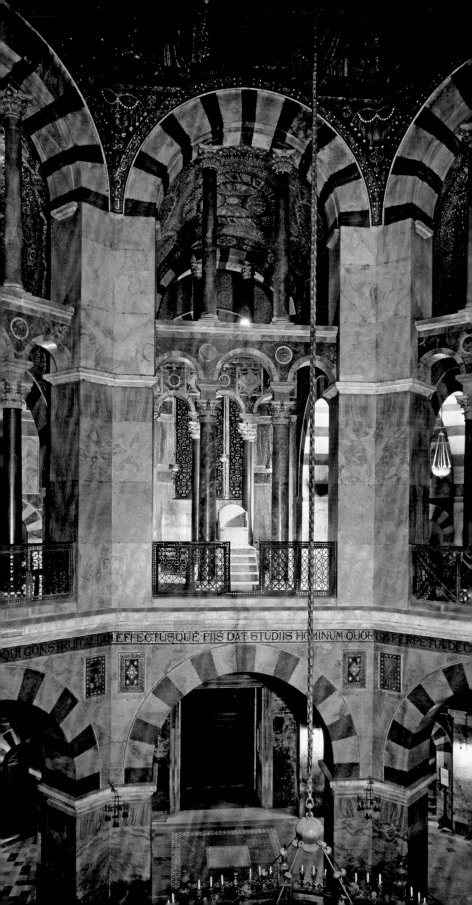

Table of Contents

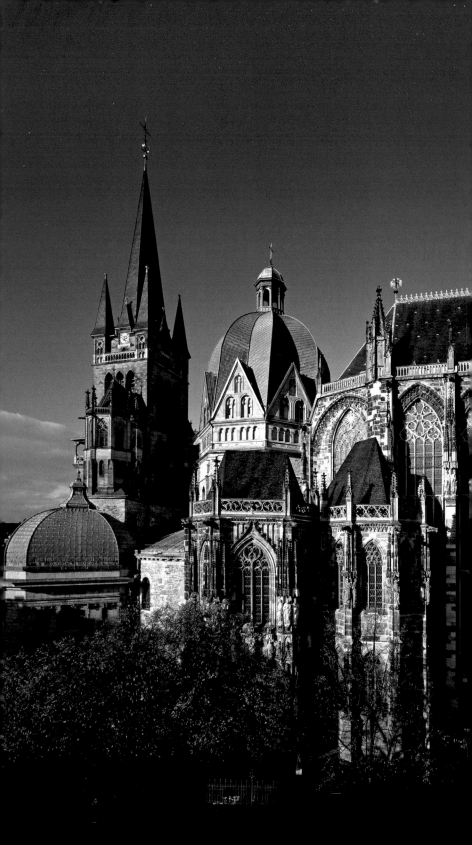

The History of the Aachen Cathedral Treasury

In memory of prelate Professor Dr.-Ing. E.h. Erich Stephany († 1990), custodian of the Aachen Cathedral and the Cathedral Treasury from 1943 to 1985.

„There I saw every glorious delight, the likes of which no one living among us has seen." Thus wrote Albrecht Dürer in the diary of his Netherlandish journey while in Aachen for the coronation of King Carl V.

This „glorious delight" has been preserved in nearly all of its entirety in the Cathedral and its Treasury. It is considered to be the most significant church treasury north of the Alps. Its lofty position is mostly owed to the fact that for centuries – from 936 until 1531 – the Collegiate Church Our Lady at Aachen was the coronation church for the Roman-German kings. Only after the coronation in Aachen was it possible for the king to be crowned emperor in Rome. Some of the acquired pieces in the Cathedral Treasury can be traced back to royal donations, while others were made for coronation ceremonies.

In this way, the valuable Lothair's Cross (c.1000) became associated with the Ottonian imperial family, as well as the Golden Book Cover, the Otto Codex, the Ivory Situla, the Golden Altar Antependium, and the Gospel pulpit. Emperor Frederick Barbarossa donated the large copper chandelier, which is located in the Palatine Chapel of the Aachen Cathedral. During his era, the shrine of Charlemagne came into existence and has contained his mortal remains since 1215. The three largest and most significant Gothic reliquaries date back to the probable donations of Emperor Charles IV: the Bust of Charlemagne and the two chapel-shaped reliquaries. In addition to a Renaissance monstrance (which became Emperor Charles V's coronation gift to the collegiate church), the goldsmith and seal cutter of Emperor Charles V, Hans von Reutlingen from Aachen, completed reliquaries, gold statuettes and choir robe brooches. From the Baroque era, church vestments have been preserved on a large scale, in addition to processional crosses, monstrances, chalices, and other liturgical implements.

The Cathedral Treasury, which has grown over the centuries, has an eventful history behind it. During the Thirty Years' War, it was emptied as the French revolutionary troops occupied Aachen and annexed the city with Roer. In August of 1794, the Treasury was whisked away to Paderborn. It was an escape of serious consequence, for the crates hidden in the Capuchin cloister were opened and three items of imperial regalia, which until then had been held at the coronation church, were removed: the Carolingian Coronation Book of Gospels, on which the king swore his oath, Charlemagne's sword, and the Bursa of St. Stephen, a Frankish reliquary. The regalia were brought to Vienna and since then, have been located with the remaining imperial regalia in the Vienna Treasury. The legal battle regarding the ownership of the imperial regalia has not yet been put to rest.

As a form of thanks for the Treasury's return to Aachen which was ordered by Napoleon I, Marc Antoine Berdolet, the first bishop of Aachen, gave significant pieces of the Treasury in 1804 to Empress Joséphine who had been visiting the spa baths in Aachen. These gifts

were the Arm Reliquary of Charlemagne (now in the Louvre in Paris) and the Talisman of Charlemagne (now in the Reims Cathedral Treasury).

Towards the end of the First World War due to impending air attacks, the Treasury was again evacuated to Paderborn and returned in 1922. At the beginning of the Second World War and along with the treasuries from the remaining churches in Aachen, the Suermondt-Museum, and the diocese churches, it was brought at first to the castle of Bückeburg. However, the castle was not suited for the storage of such large objects.

Thus in 1941, after Heinrich Himmler had compiled a list of items which were „significant" and „insignificant" for the Reich, the 14 „significant" items were brought to the castle of Albrechtsburg in Meißen/Sachsen. The „insignificant" items returned to the Aachen Cathedral, where they were carefully immured at the south tower of the Carolingian west wing.

On September 13, 1944, as the remaining citizens of Aachen were evacuated from their city towards Thuringia in the east, the „significant items" of the Cathedral Treasury returned to the Rhineland: the Shrine of Charlemagne, the Shrine of the Virgin Mary, the Bust of Charlemagne, Lothair's Cross, the ivories and codexes, and the large Gothic reliquaries of the Treasury. The transfer was made possible by the urging of the Reich conservator Robert Hiecke and the provincial conservator Franz Graf Wolff-Metternich, the latter of whom was in close contact with the cathedral chapter and city administration. The city of Siegen was reached without incident and the treasure was hidden in an abandoned ore mine tunnel. Aside from Beethoven's original music compositions, the Roman wooden doors from St. Maria in Capitol/Cologne, and the most valuable parts of the Rhenish museums,

5000 people also found shelter there. On Easter Monday in the year 1945, a young cathedral curate named Erich Stephany made his way to Siegen on the orders of the Aachen bishop and the cathedral chapter. Accompanied by the American officer responsible for the protection of art, Captain Hancock, Stephany was to secure the six crates (containing the Cathedral's valuables) and to confirm that they had at least not sustained any damage. Again on May 7, 1945, he went to Siegen with the hope of bringing the Treasury back; meanwhile, the handover of property was delayed due to the surrender that ensued. On May 26, 1945, the Treasury finally made its way back to Aachen. Captain Hancock, the art protection officer, had safeguarded it from a new exile to Marburg by arbitrarily negotiating against the military bureaucracy. Together with the copies of the Aachen imperial regalia and the doors of St. Maria in Capitol, he had the Treasury placed onto a truck and brought back to Aachen. In 1978, the Cathedral and its Treasury became the first architectural and art historical ensemble in Germany to be added to the UNESCO list of protected cultural heritage sites.

In 1975, based upon the significance of the Cathedral Treasury, the Ministry for Regional Planning, Building, and Urban Development chose to erect a trial bunker in Aachen. Because only short transport routes could have guaranteed the safe rearrangement of the Treasury in an emergency, the cathedral chapter decided to build within the close vicinity of the underground bunker at the west side of the cloister. The planning and execution of both projects was undertaken between 1975 and 1979. In 1979, the Cathedral Treasury, which had formerly occupied a 90 square-meter room from the Carolingian era on the east side of the cloister, was opened anew. In

three rooms measuring approximately 490 square meters, the exhibits were displayed in chronological order. Over time, however, technical shortcomings surfaced that posed a potential threat to the Treasury. Thus, the cathedral chapter decided in 1994 to redesign the Treasury's installation in order to sufficiently address its conservational, technical, and safeguarding requirements. The concept was developed by Dr. Herta Lepie, Dr. Georg Minkenberg, Dr. August Peters, and Dr. Hans-Karl Siebigs. The architect Dipl.-Ing. Winfried Wolks was commissioned to complete the project. The Cathedral Treasury was opened in the winter of 1995.

The exhibition area was expanded to 600 square meters and did not only offer extra space for temporary exhibits, but made accentuation possible with the creation of compartmentalized rooms. The exhibition of the Treasury is organized according to themes, which are clearly apparent by the content-related references of the pieces to one another. They interpret the significance and the history of the Church, which as the Church of St. Mary, became the coronation church of the German kings and has been a destination for pilgrims since the Middle Ages.

On the ground floor, the three themes of „Charlemagne," „The Coronations," and „The Liturgy" are located. On the upper floor are the two themes of „The Pilgrimage Church and its Reliquary Treasure" and „The Church of St. Mary," as well as a room devoted to temporary exhibitions.

The large vaulted room located downstairs features the extensive Textile Treasury of the Cathedral, which due to conservation issues, are displayed on a rotating basis. The works of art, which were created for the Cathedral's decoration during the Late Medieval and Early Modern periods, will to some extent, continue to have their place within the chapels of the Cathedral.

To conclude this introduction are Erich Stephany's reflections on the Aachen Cathedral Treasury, which continue to bear relevance today. „We sense that all of the radiance which spreads from this treasure is connected with the observance of the mystery of salvation. Observance – festive observance – invigorates the cult of the community and elevates it into the proper sphere. We celebrate these feasts, despite the misery of the world and bestow them with an uplifting effect through the works of art. Via the shimmer of gold, the radiance of precious stones, we experience something of the glory towards which we aspire. In the beauty which art conveys, the beauty of God is reflected as it is revealed to us in the Book of Revelation."

Herta Lepie

Charlemagne

The Aachen Cathedral and its Treasury are closely linked to the memory of Emperor Charlemagne (742-814). As the first ruler of the Christian Middle Age – of the Western world – Charlemagne wanted to establish the "New Rome" in memory of the splendor and grandeur of the Ancient Roman Empire. At his court, he collected scholars from all across Europe who became his advisors. The greatness of Charlemagne, who was already referred to as "the Great" during his lifetime, resided not primarily in his success as a political power and the unity of his vast empire, which stretched across all of Europe. Rather, it was the capacity to see the importance and opportunity of spiritual and cultural impulses, which he was able to borrow from Roman Antiquity. Up until the late Middle Ages, Charlemagne served as an example for emperors and kings. HL

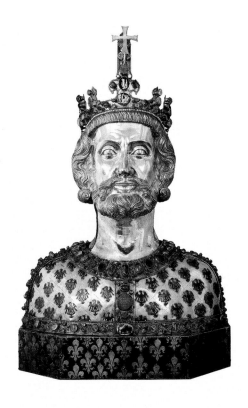

Charlemagne

- Cologne (?), early 14th century
- Oak with nominal vestiges of the original form
- H. 108 cm

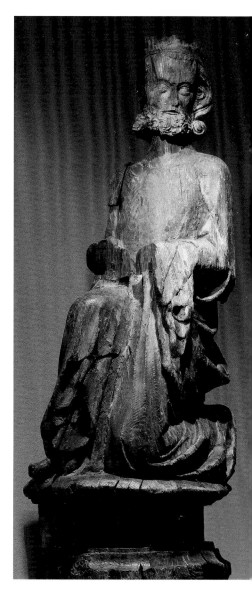

The figure of a kneeling king identified as Charlemagne, was rediscovered in 1933 via a reproduction in Montfaucon's *Les Monuments de la monarchie francaise I*, 1729. It shows Charlemagne with al-mond-shaped eyes and a thin-lipped mouth. In keeping with French exam-ples, as seen in the Bust of Charlemagne which emerged shortly thereafter, Char-lemagne's face is framed by a stylized head of curly hair and a beard. In the 1729 illustration, Charlemagne carried a replica of the Aachen Church in his now-lost hands. As in the corresponding roof relief on the Shrine of Charlemagne, he most likely handed the replica over – in the manner of one of the three Kings – to a Madonna and Child sculpture which no longer exists. In doing so, it con-firmed the dedication and consecration of the church Charlemagne had built to honor the the Virgin Mary. A correspond-ing image also exists in the outer wings of the Treasury's Life of the Virgin panel, made in about 1485.

The Charlemagne figure was probably later a component (along with the Pros-erpina Sarcophagus) of a so-called Char-lemagne memorial in the lower ambula-tory of the Palatine Chapel.

In addition to the Bust of Charlemagne, stylistic comparisons can be made to reliquary portraits from Cologne. GM

Seal Stamp of the Aachen Collegiate Church

- Aachen, 1528
- Marked with the master's mark of Hans von Reutlingen and the municipal inspector
- Hammered and embossed silver
- H. 8.7 cm, W. 7.05 cm

The seal assumes the shape of an almond (vesica piscis, mandorla). As the symbol of the patron saint to the Aachen Cathedral, it displays the Annunciation of the angel to Mary. The Annunciation takes place in a room which is represented by columns, a baldachin, and foreshortened windows. Beneath the room, two cherubs hold the chapter's coat of arms, while a banner decoratively frames the scene.

On December 11, 1528, the collegiate chapter elected to use the new seal in place of the old, worn-out one. The Aachen city archives contain a document with a chapter seal from 1226 which shows an enthroned Madonna and Child. As the shape of the seal is the mandorla and a 14th-century seal shows the Annunciation, the seal by Hans von Reutlingen thus perpetuates the traditional form of the chapter's seals. Hans von Reutlingen was the most prominent goldsmith in Aachen during the transition from the Gothic to the Renaissance. He was the seal cutter for Emperor Maximilian I and Emperor Charles V.

HL

Proserpina Sarcophagus

- Rome, early 3rd century A.D.
- Marble
- L. 220 cm, W. 64 cm, H. 58 cm, inner measurement L. 204 cm

The high relief of the sarcophagus shows the ancient Greek-Roman myth of the abduction of Proserpina. Proserpina is abducted by Pluto, the god of the underworld. He is assisted by the

goddess Minerva and Cupids, as well as Mercury, the messenger of the gods, who drives a quadriga into the underworld. At Mercury's feet is Cerberus, the two-headed hellhound. From the earth, the giant Enecladus emerges to receive the carriage. Beneath the horses lies the nymph Zyane. Upon a dragon-pulled wagon steered by a winged deity, Ceres, Proserpina's mother, with torches in hand, follows in pursuit while Venus, an accomplice to the abduction, flees the scene. Beneath her, two companions of Proserpina have stumbled to the ground in shock while attempting to protect their flower-filled baskets.

The direction of the portrayal makes clear the senselessness of Proserpina's struggle: the passage of time leads inevitably to the death of man.

The left narrow side shows the two companions and a boy picking flowers, while upon the right, a youth accompanied by two shepherds collects fruit from the cornucopia of genius. In this manner, the sarcophagus also embodies the seasons: Spring (left narrow side), Summer (front side), Autumn (right narrow side), and Winter (undecorated reverse side).

The sarcophagus, now without a cover, is among the ancient works of art which Charlemagne had brought from Italy to Aachen. It may be that the conclusion of the depicted myth (in which Ceres's pleas succeeded in permitting her daughter to spend two-thirds of each year on earth) allows for a Christian meaning. The slim possibility exists that the sarcophagus contained the mortal remains of Charlemagne from his burial on January 28, 814, until 1165. When Barbarossa had Charlemagne canonized, his mortal remains were brought to the altar for veneration: Charlemagne was immediately buried in the manner of the Western Roman ruler. Later, the empty sarcophagus (along with the wooden figure of Charlemagne now on display in the Treasury) probably became part of the (so-called) Charlemagne memorial in the lower ambulatory of the Palatine Chapel. During the French occupation of Aachen, the sarcophagus was taken along with the antique columns of the Minster (Cathedral) to Paris in 1794. In 1815, it was brought back to Aachen; in 1843, it was severely damaged after an attempt to heave it up to the gallery of the Nikolaus Chapel. Closely related to this sarcophagus is the one in the Capitoline Museum in Rome.

GM

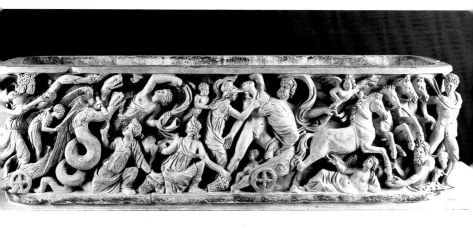

Bronze Female Bear, so-called She-Wolf (Cathedral)

- Roman or Hellenistic, 2nd century A.D.
- Hollow cast bronze
- H. 85 cm, W. 75 cm, D. 95 cm
- Left front leg replaced in the 19th century

The beast sits upon its back legs, its front legs splayed, and turns its head to the left with its mouth wide open. The body is covered with shaggy fur. The quality of the cast is extraordinarily high and speaks in favor of the work's origin from a prominent bronze workshop. The hole in the chest might have been cut after the cast was made. It has led to the presumption that the animal – like the Roman she-wolf in the Lateran of Rome – served as part of a fountain. Whether Charlemagne had the bronze brought to his castle in Aachen in order to establish it as a sign of the "Roma secunda" is questionable and cannot be proven. The bronze was first mentioned in 1414 as a "lupus" (wolf) in the coronation report of King Sigismund. At the coronation of Maximilian I in the Aachen Cathedral on April 9, 1486, it was identified as a "lupa" (she-wolf) (Nesselrath, 103f.). The bronze entrance of the Aachen Cathedral has been named the "Wolf's Door" after this work.

HL

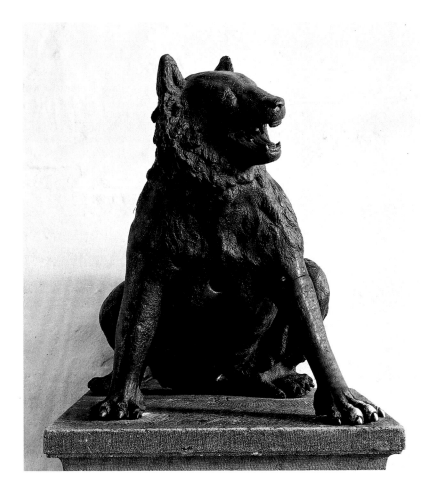

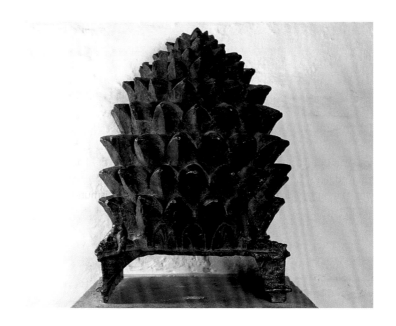

Pine Cone (Cathedral)

- Aachen (?), about 1000
- Single-cast bronze with little retouching, tip probably replaced in the 19th century
- H. 91 cm, W. total pine cone 68 cm, D. square base 59.5 cm
- Like the Bernward Column (around 1020) in Hildesheim, the pine cone was cast from a zinc-free alloy.
 The copper most likely came from the mines of Rammelsberg near Goslar (Effenberger/Drescher, 116,118).

The pine cone rises above a square base, with which it was cast as a single unit. The base yields an inscription in Latin that is only partially preserved along two sides. The translation reads:
„The waters are bestowed upon the world, that always cause it to flourish; the fruitful Euphrates, as swift as an arrow of the Tigris."
The inscription of a third side was provided in 1620 by Petrus à Beek. Its translation reads: Udalrich, the pious abbot, gives thanks to the Creator." (Giersiepen, 12f.). Embodiments of the four rivers of Paradise that are mentioned in the inscription are located at the corners of the base. Only fragments of these allegories have been preserved. The pine cone consists of 129 scales which are arranged in nine overlapping rows. The holes at their tips imply that the pine cone once functioned as a water spout. The ledge running along the lower part of the base indicates that the base was originally embedded into a capital and had crowned a column that had stood in the center of a fountain's basin. Like the Roman *pigna* located in the atrium of Old Saint Peter's in Rome, the pine cones made in Aachen during the Ottonian Period were probably on display in the atrium of the Aachen Cathedral. „Pine cones were common in Antiquity and Middle Ages, as well as in Byzantine and the West" (Effenberger, 115f.).

HL

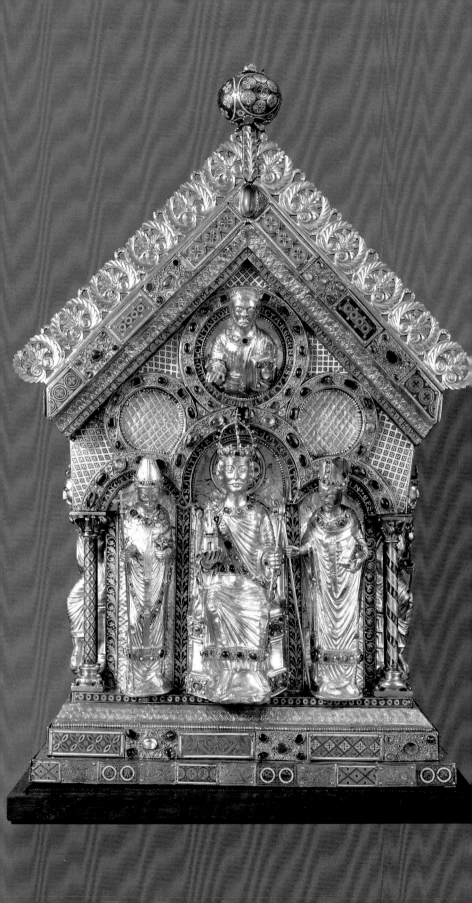

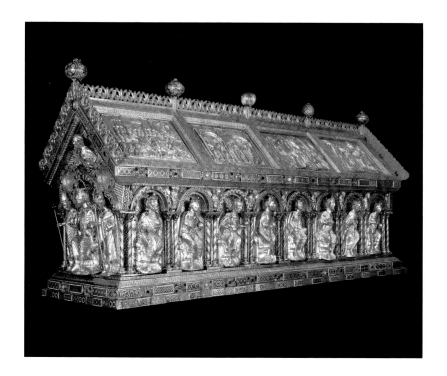

Shrine of Charlemagne (Cathedral)

- Aachen, between 1182 and 1215
- Oak core, hammered and gilt silver, partially engraved and cast, gilt silver plate, brown varnish, filigree work with embedded precious stones, champlevé, stamped bands
- L. 204 cm, W. 57 cm, H. 94 cm. The length of the base matches the inner length of the Proserpina sarcophagus. The shrine was stabilized and restored between 1982 and 1988 in the goldsmith's workshop of the Aachen Cathedral. The original medieval gold leaf was successfully uncovered. Dating analysis for the oak core indicates that the tree was felled in 1182.

The shrine is shaped like a church with a single nave. The shrine was completed in 1215 at the coronation of King Frederick II of Hohenstaufen, who drove in the final nail. Since then, it has contained the mortal remains of Charlemagne, who was canonized in 1165 by Emperor Frederick I Barbarossa. This canonization made manifest the idea of the Hohenstaufen Empire. The shrine, with its pictorial program, became the visual symbol of the Holy Roman Empire. In place of saintly figures and apostles, eight kings of the Holy Roman Empire are enthroned upon each of the long sides of this "church" as the successors to Charlemagne, from Louis the Pious to Frederick II of Hohenstaufen. At the front, Charlemagne sits enthroned beneath Christ, who blesses him, and is accompanied by the standing, albeit smaller figures of Pope Leo III and Archbishop Turpin of Reims. The rear is reserved for St. Mary, the patron saint of the collegiate church, and the Child. Upon the roof reliefs is depicted the legendary biography of the Emperor, who led his life according to God's calling. The literary

source for this relief is a 12th-century manuscript known as the Pseudo-Turpin, which chronicles the fabled life of Charlemagne. The original is located as the third book in the Calixtinus Codex in Santiago de Compostela.

The shrine follows the tradition of shrines from the Meuse region. Apart from the inscription relief, it is stylisti-cally consistent. Its master probably came from the workshop of the shrine of Saint Servatius in Maastricht, while a second master, who began work of the Shrine of the Virgin Mary after 1215, created the inscription relief (Dom-kapitel Aachen, Der Schrein Karls des Großen) .

HL

Cloth with Quadriga (exhibited periodically)

- Byzantine, late 8th century (?)
- Silk samite, thread count 68: 68.5 cm
- H. 76 cm, W. 75 cm

The crimson-hued samite weave illus-trates a Late Antique arena scene, using a yellow-brown pattern in front of a dark-blue background. Within a circular medallion bordered by heart-shaped leaves, a quadriga is displayed symmet-rically along its axis. The reins of the four richly harnessed horses are entwined about the arms of the armor-clad, curly-haired charioteer leading them, his arms extended at right angles. Two slaves clothed in tunics and fluttering cloaks approach at a run, each holding a vic-tory wreath and whip. Beneath and in front of the horses, whose bodies are partially displayed from the front as well as in profile, two youths empty sacks of coins upon an altar. This is a Byzantine imperial allegory for generosity.

A quadriga is a two-wheeled war- and race chariot drawn by four horses har-nessed alongside one another. During Antiquity, these chariots were employed to transport the celebrated commander during the triumphal procession, but were also used during the popular char-iot races within the arena. Even in the Carolingian Period, artists of the Byzan-tine region drew upon this ancient mo-tif glorifying the strong, victorious ruler. Originally, additional circular medallions were connected to the surviving medal-lion by smaller circles. These small rounds, which were located above, be-neath, and to the side of the large me-dallions, were also decorated by heart-shaped borders. In the pendentives be-tween the medallions, pairs of ibexes face one another, branches in their mouths.

The silk displays a mixture of Persian (ibex) and Byzantine (youths who throw coins) elements and is cited as the oldest and most significant Byzantine woven cloth containing figures. It was probably a gift to Charlemagne, having been among his burial cloths at his funeral on January 28, 814.

However, research dates this cloth to between the 6th and the end of the 8th century. Related to it is the 6th-century, Syrian cloth, referred to as the "Brilliant Shot of Bahram Gor" cloth from St. Cu-nibert in Cologne.

A piece of the cloth, taken from Aachen in 1850 and of nearly the same size, is located in Paris.

GM

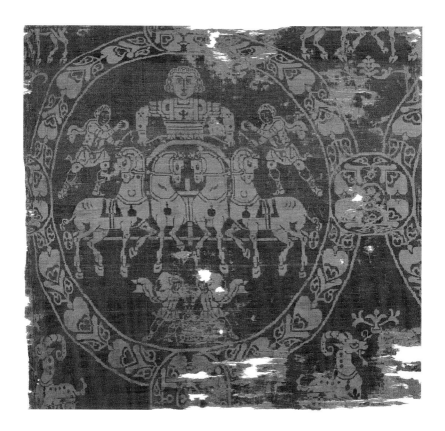

Cloth with Elephants (Shrine of Charlemagne)

- Byzantine, before 1000 (?)
- Silk samite
- gr. H. 162 cm, gr. W. 137.5 cm

The twice-dyed crimson silk samite features a yellow-brown, white, green, and blue pattern upon a red background of circular medallions, with a width of 78-80 cm. Placed in vertical and horizontal rows of four are elaborately-harnessed elephants, each featuring a segmented trunk, tasseled tail, saddle blanket, and cinch. Like mirror images, they stand across from one another in front of stylized trees of life. The circular medallions are filled by palmette motifs between two rings of pearls. Rosette petals, which contain ringed, geometric ornaments of circles and squares, fill the pendentives between the circular medallions.

The silk, one of the most brilliant examples of Byzantine weaving, is one of the large Byzantine textiles which incorporates Sassanian elements. The motif of the elephant refers metaphorically to the strength and placidity of the ruler. The lower border displays a seam with a height of 3.5 centimeters, shaped by two straight bars with oval and circular unjoined discs. The upper bar is surrounded by two narrow bands at the top and bottom. Two lines of Greek script have been twice-woven into the seam. It notes that the silk was a product of the textile manufacturer of Constantinople while the imperial official Michael was the chief of the treasury and Petros was the archon (ruler) of Zeuxippos. Zeuxippos was the location of the imperial silk manufacturer. Due to

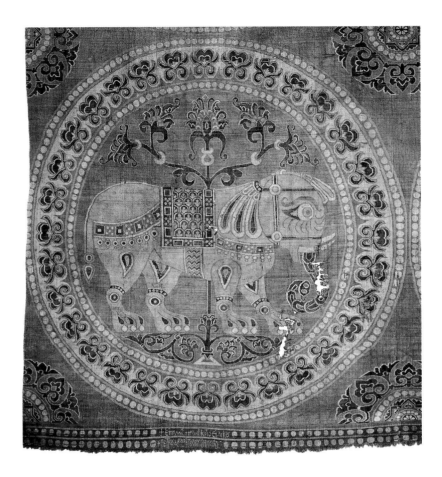

the missing indiction (15-year cycle), the dating of the silk has been based upon the titles in the inscription and was most recently assigned a range between 843 and 1088.

The original weave width must have added up to at least two circular medallions, or 156 centimeters. Because of the technical difficulties in manufacturing which had not yet been overcome (as seen in the comparison to the imperial silk of the Cloth with Griffins), a dating between 976 and 1025 has been suggested.

The cloth with elephants has been authenticated as a burial shroud of Charlemagne, for in 1988, cloth fibers were found adhering to his remains. The silk may have belonged to the dowry of Theophanu, the Byzantine mother of Emperor Otto II. According to tradition, the cloth was spread over the remains of Charlemagne at the opening of his tomb in 1000 and came with him to the Shrine of Charlemagne. It has been located there since 1988.

GM

Cloth with Rabbits (Shrine of Charlemagne)

- Sicily, early 13th century (?)
- Silk samite
- H. 125.5 cm, W. 239 cm

Among the textiles which were located in the Shrine of Charlemagne until 1949 and again since 1988, is also the one referred to as the Cloth with Rabbits, a complete silk cover with all four selvages preserved.

The yellow, white, blue, and green pattern upon a violet background displays palm-like trees of life in twelve overlapping rows. These are surrounded on either side by rabbits and birds and connected by arabesque vines. The border consists of a striped pattern and looped fringe from the twisted threads at the edges.

According to tradition, Emperor Frederick II laid the silk cloth in Charlemagne's shrine on July 27, 1215. As a result, the cloth, whose provenance and dating are ultimately unknown, is for the most part thought to be an early 13th-century product of Sicily.

In terms of its weave, edging, and the tendril pattern, the material corresponds to a choir robe from Dokkum (Museum Catharijneconvent Utrecht), but is more stylized as a whole.

GM

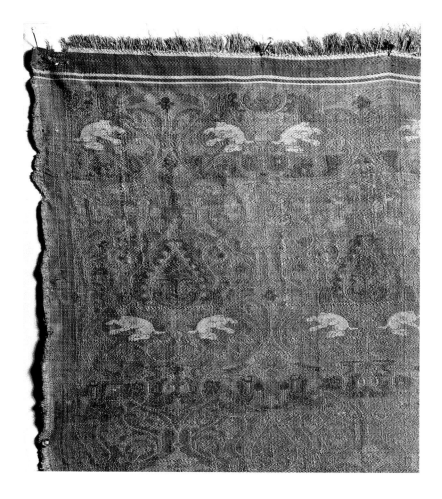

Cloth with Griffins (exhibited periodically)

- Lucca or Venice, early 14th century
- Silk
- H. 101 cm, W. 124 cm

Upon a light green background, five alternating rows of twelve griffins and twelve peacocks face one another in pairs. They hold lotus palms in their claws and are surrounded on either side by small ibexes (griffins) or tendril leaves (peacocks). Between the peacocks' throats, eight-sided rosettes and tendrils are interspersed. Heads, wings, breast plates and bird claws are stitched in gold, while the remaining patterns are rendered in pink, white, and brown.

According to tradition, Emperor Charles IV laid the cloth over the mortal remains of Charlemagne in his shrine in 1349.

The same material is located in Muenster (Bischöfliches Diözesanmuseum) and in Vic, Spain (Bischöfliches Diözesanmuseum). GM

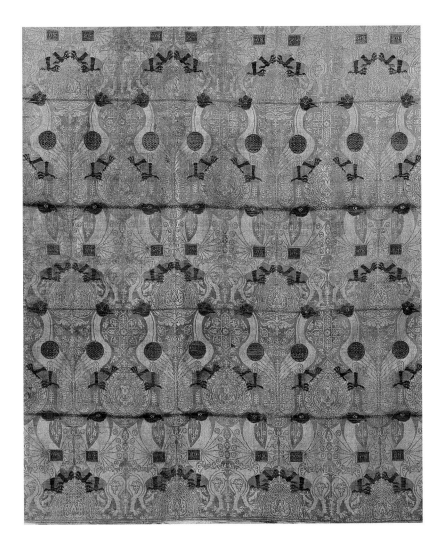

Carolingian Ivory Book Cover

- Court School of Charlemagne, Aachen, early 9th century
- Ivory
- Silver frame and bound hymnal, 14th century
- H. 31.7 cm (both), W. 10.8 cm (both)

Portrayed upon square panels are six events from the Resurrection of Christ (Luke 24). Framed by acanthus leaf ornamentation and pearl borders, they are clearly separated into distinct fields. The right side shows the front; the left side shows the back. On the lower right is the meeting on the way to Emmaus (Luke 24:15), on the middle right is the Emmaus meal (Luke 24:30), and on the upper right, the disciples discuss in Jerusalem their meeting with Christ (Luke 24:35). On the upper left, Christ shows his wounds (Luke 24:39-30), the middle left shows the blessing of the disciples outside town (Luke 24:50), and on the lower left, is seen the reading of the Prophets (Luke 24:44).

The order of the relief images does not quite correspond with the chronology of the text. Nevertheless, it appears that in this unique series from Aachen, the artist appears to have oriented himself using sources of an extensive cycle from Late Antiquity. This included the events of John which took place after Easter. Thus, the depiction of Christ showing his wounds is apparently a Thomas scene that has been moved to an outdoor setting (John 20), while the Emmaus meal marks an indoor representation of the meal at the Sea of Galilee (John 21,12ff). The diptych format corresponds to that of a Carolingian sacramentary from Cambrai (made in 812), which in terms of its inscription, is designated as an exact copy of the authentic ancient work of Aachen, the Sacramentary of Adrian I (Gregorianum). It follows that the Aachen tablet which was re-appropriated in the 14th century most likely constituted its original binding.

Chronologically and stylistically, the Aachen ivory book cover is similar to an ivory cover in Narbonne with the Crucifixion of Christ, another in Darmstadt with the Ascension, and in regard to its border ornamentation, the Lorsch Book of Gospels. GM

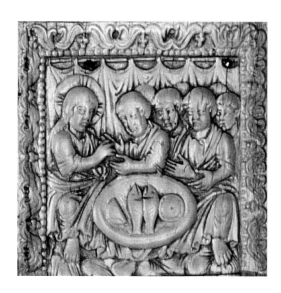

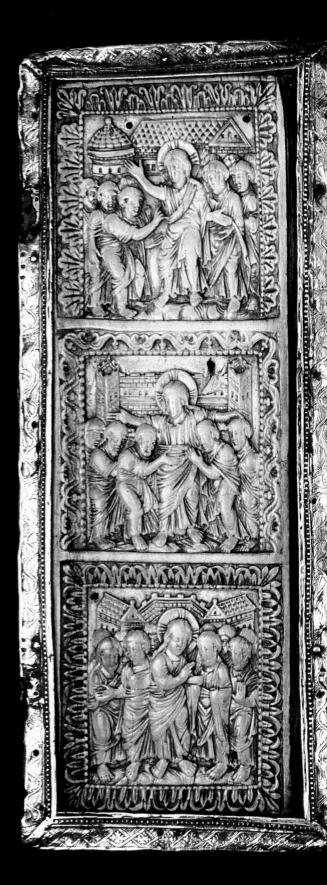

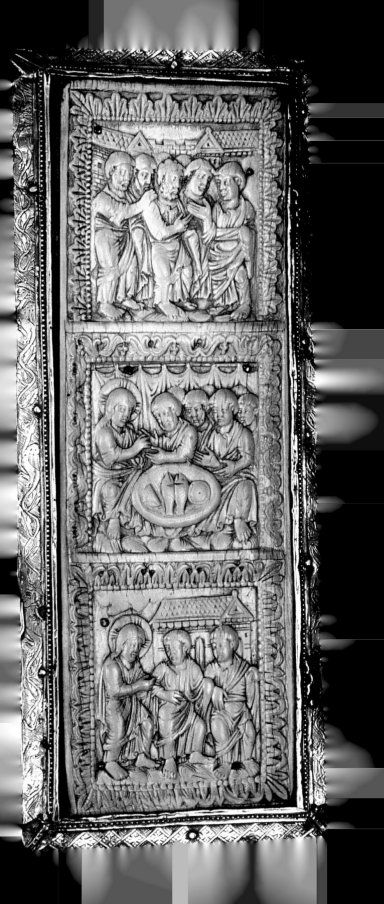

Carolingian Book of Gospels (exhibited periodically)

- Court School of Charlemagne, Aachen, early 9th century
- 280 quaternion sheets, parchment
- H. 30.5 cm, W. 24 cm
- Until 1972, it was associated with the Ottonian Golden Book Cover (front) and with the Roman Silver Book Cover (back) until 1870; newly bound in 1972.

The manuscript contains the texts of the Four Evangelists with the corresponding arguments (prefaces), as well as the Hieronymus prologue (fol. 2r–5r) and the so-called Damasus letter (fol. 5–7v). They are written in single columns using Carolingian miniscule script. Titles and headings are emphasized using Capitalis rustica (canonized or rustic capitals).

The canon charts (tables correlating to the Gospels) of the Gospels are located on twelve pages (fol. 8v–fol. 14r) within a classic architectural framework. They refer to a template from 400 B.C. and are the only example within Carolingian book illumination to feature the entablature format as well as a single-page miniature (fol. 14v) placed in front.

In an unusual single-page display, all four Evangelists appear upon a hilly landscape with a distant horizon, creating an illusionary space around each one of them. The landscape disappears behind twig-like tree silhouettes into a rose-hued evening sky. The age-related color transparency allows for the viewing of earlier sketches, showing that an architectural background with battlement-crowned walls was initially planned. The Evangelists with white halos are portrayed in various stages of life, ranging from the young man to the very old. Moreover, as embodiments of the four temperaments, they are clothed in the manner of ancient philosophers in white, billowing togas. They sit in front of their desks and are seen writing (Matthew), dipping a quill into the ink (Mark), reading (Luke), and meditating over what has been written (John). In contrast to the ancient authors, the four authors of the Evangelists are not autonomous, but instead are clearly servants of a higher power, as evidenced by the presence of their symbols. The painted golden frames with the illusionist filigree and costly gems emphasize the preciousness of the Word of God that have been recorded by the Evangelists.

The Evangelists are turned away from one another and yet, as suggested by the frame and the landscape, belong to one another. Hence their four Gospels, in their solidarity and concordance, provide the clear sign for the truth of the one Gospel that they have created together, as Augustine created one world from the four parts of the earth. Indeed, the configuration of the Evangelists in the four corners of a landscape refer to the four world regions as a square. The Evangelists define the places of the world and illustrate its system. Their four symbols refer to the varied manifestations of the Word in the world.

This unique image was created by a Greco-Italian artist who was familiar with the paintings of Late Antiquity.

Aside from a decorative page in gold and silver Capitalis rustica with the title of the Gospel according to Matthew (fol.19v), the manuscript (which is considered incomplete in terms of book illumination) contains no further miniatures. Upon the final page of this so-called Treasury Book of Gospels, which belongs to the original liturgical implements of the Marian church, is the Capitulare Evangeliorum, or Index for

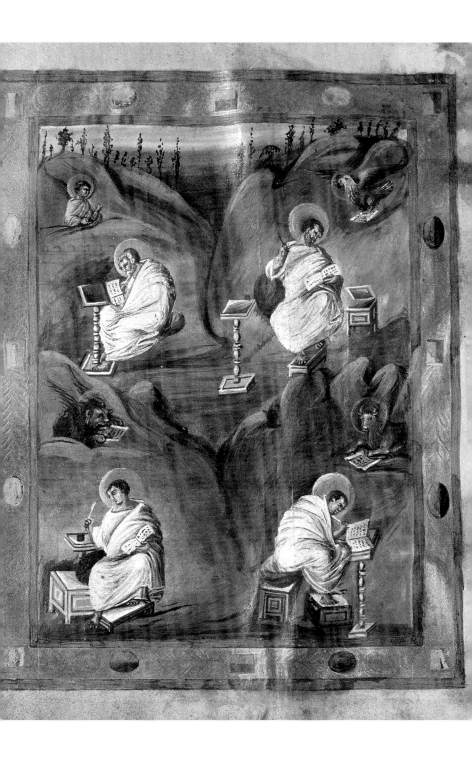

the Sunday and holiday Gospel readings (fol. 258r).

Stylistically, the manuscript belongs to the group of the so-called Coronation Gospels in Vienna, which until 1794, was also located in the Aachen Cathedral Treasury.

GM

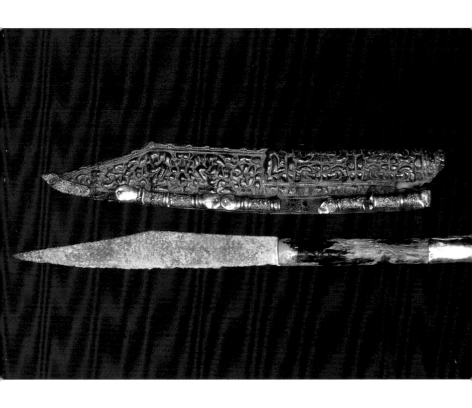

So-Called Hunting Knife of Charlemagne

- Knife: Pattern-welded iron,
 Anglo-Saxon or Scandinavian,
 8ᵗʰ century
- Horn handle with brass fittings
- Scabbard: 10/11ᵗʰ century (?)
- Leather
- L. of the knife 52.5 cm, W. ca. 4.5 cm,
 L. of the scabbard 46.7 cm, D. 7.5 cm

The knife, a so-called seax, has been traditionally associated with Charlemagne. The blade is pattern-welded iron. Its quality and technical report allow for a dating to the 8ᵗʰ century. Along with the Petrusmesser, or Knife

of St. Peter of the Bamberg Cathedral, it is the sole known medieval knife which has been kept above ground; that is to say, it has had particular significance from its inception. All remaining pieces of this type have been archaeological finds.

The knife scabbard is decorated with sumptuous filigree plaques, precious stones, and colored glass. The embossed leaf- and braided ornaments suggest an Anglo-Saxon origin, as well as the 11ᵗʰ-century inscription „BYRHTSIGE MEC FECID" (Byrhtsige made me) in Anglo-Saxon script. HL

Olifant

- Lower Italy (Saracene), about 1000 or later; or Oriental, 11ᵗʰ century
- Ivory
- Arch span 58 cm; radius of the lower opening 13 cm
- Carrying strap: Liège or Aachen, late 14ᵗʰ century
- Red velvet with gold braid (restored), on this and the strap closure appears the inscription "dein eyn" four times in Late Gothic, silver-gilt script. The letters and closure belong to a belt trimming.

The tip of the elephant tusk – faceted sixteen times – is unique prior to the 15ᵗʰ century. Each point is flanked by spiral tendrils; in the 19ᵗʰ century, restored silver-gilt, jewel-encrusted metal fittings surrounded the horn. The horn's mouth is accentuated by animal scenes. Two kneeling deer with turned heads are shown, as well as two bulls who run away from one another. The modeling of the animals is limited to short-stroked marks upon the body. In all of the figures, the spine terminates into an as yet unexplained ornamental motif at the haunches. A small gold-plated silver ring, most likely from the late 14ᵗʰ century, protects the opening from breakage.

The olifant, originally a bugle for hunting (animal scenes), has been thought to be Charlemagne's. It was given to him by Harun al Rashid or came from Abul-Abbas, the elephant at Charlemagne's court. Before his death in the battle of Roncevaux, Roland used a similar bugle – or olifant as it was called in the 12ᵗʰ-century legend – to summon Charlemagne for help. In cloisters and monasteries, such horns have been used since Carolingian times (Capitulare de Villis) to give the signal for daily prayer. This may have been the case in Aachen as well. The horn bears no evidence of later use as a reliquary vessel as previously thought. Rather, it was venerated as an independent legendary relic belonging to Charlemagne.

The animal representations find parallels in Persian silks of the late 10ᵗʰ century. Closely related olifants are in Berlin (with war-related damages) and Paris.

GM

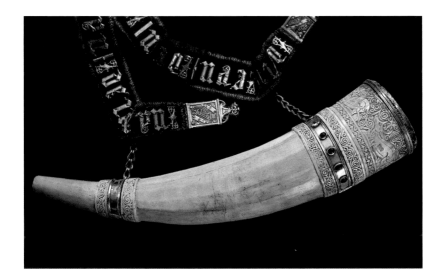

Citrine

- Yellow, transparent quartz
- 11th-century filigree work located beneath the base
- H. setting 8 cm, W. 6.5 cm
- Gilt silver base

The stone and claw setting were not part of the plate. The filigree work beneath the base shows a cross-shaped recess, suggesting the former attachment of a cross relic. The size of the recess corresponds to the cross relic on the Charlemagne Reliquary. It is assumed that the citrine served as a clasp on the breastplate of the Charlemagne bust. HL

Pectoral Cross of Charlemagne

- Aachen, circa 800 and 1165
- Hammered silver, engraved and gilt, with precious stones and pearls
- H. 8.5 cm

According to the most recent research, the hammered and gilt silver body of Christ came from a Carolingian cross pendant which also assumed the form of a hinged cross reliquary. It is likely that this cross concerns the "golden cross" which, according to the chronicle of Thietmar of Merseburg, Emperor Otto II took from the neck of the deceased emperor when the grave of Charlemagne was opened. The rolled silver with the body of Christ was stored in a new, silver-gilt cross reliquary with an engraved Tree of Life on its back, perhaps on the occasion of his canonization in 1165. The translation of the Latin inscription reads, "Behold the cross of

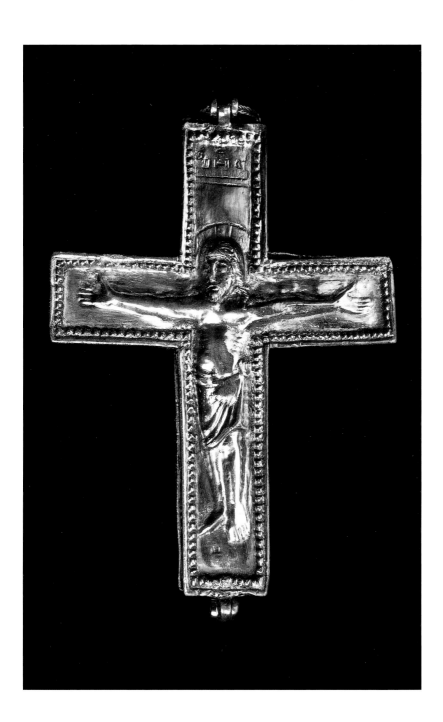

the Lord, flee ye adversary powers, the lion from the tribe of Judah and the roots of David has triumphed." Located within a small silver-gilt cross inside the reliquary is a splinter from the wooden cross of Christ. The precious stones and pearls were added in the mid-14th century during the time of Charles IV.

The pectoral cross was severely damaged during a bomb attack in 1941 and restored in 1972.

GM

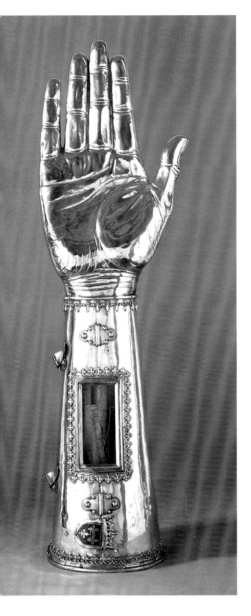

Arm Reliquary

- Lyon (?), France, 1481
- Gilt silver
- H. 85 cm, base diameter 19.9 cm and 17.1 cm
- A "speaking" reliquary, whose form indicates the type of relic stored within it.

When the Aachen Shrine of Charlemagne was opened in 1843, a document from October 12, 1481 was found attached to the wooden door of the shrine. It reported that King Louis XI of France had allowed an arm relic from Charlemagne to be transferred into the Arm Reliquary. The French royal house is indicated by the coat of arms with three fleurs-de-lis and the fleur-de-lis crown placed sideways beneath the small window. At the suggestion of King Louis XI, Charlemagne has been honored on his death anniversary of January 28 as the forefather of the French kings since 1474. In 1481, Louis vowed that he would donate a reliquary to the Aachen Cathedral, which is confirmed by the aforementioned document.

At the celebration of festive masses, such as the High Mass which occurred in 1775 in the Aachen Cathedral to honor the coronation of King Louis XVI of France, the arm reliquary stood together with the Bust of Charlemagne upon the altar. HL

Bust of Charlemagne

- Aachen, after 1349
- Crown Prague (?), before 1349
- Wood, hammered and partially gilt silver
- H. 86.3 cm, Base width 57.2 cm
- Silver eagle appliqués, borders of precious stones using antique gems
- Restored 1870 and 1926, conserved in the goldsmith's workshop of the Aachen Cathedral 2004-2005.

The reliquary contains the skullcap of Charlemagne. According to Aachen tradition, the reliquary was a donation

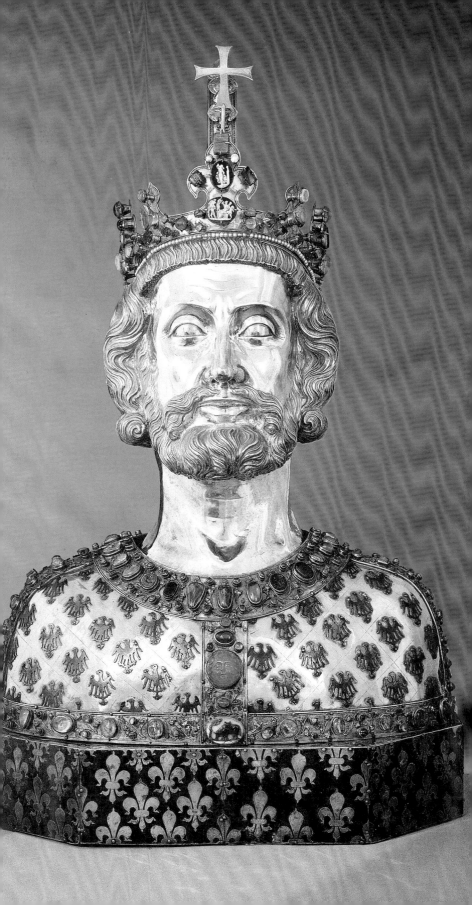

from Emperor Charles IV, who – after the preceding coronation in Bonn – was crowned on July 25, 1349 in Aachen. This donation, while not officially documented, could be true given Charles IV's high esteem for Charlemagne. With the eagle and the fleur-de-lis, the reliquary bears the visible icons of the Holy Roman Empire and France. It stands upon an octagonal base adorned with fleurs-de-lis, upon which sides can be seen two openings for the insertion of a carrying stick. The reliquary was carried during processions and at coronations, it was carried towards the king about to be crowned as he entered the Cathedral, thus making Charlemagne appear to receive his rightful successor. Broad borders with precious stones and antique gems line the breastplate decorated with the eagle motif. The face of the Emperor is powerfully rendered; his facial contours are sharply defined. The reliquary follows the tradition of 13th-century representations of French kings. Although it does not have the character of a portrait and is more so an idealized image of the Emperor, individual facial features can be detected. This is also evident in the image at the Louvre in Paris of John the Good, King of France (1350-64). It remains possible that the goldsmith from Aachen who created

the reliquary bust was trained in France. According to the newest historical research, there exists hardly any doubt that Charles IV was crowned on July 25, 1349 with the crown worn by the Bust of Charlemagne and not with that of the imperial jewels, which were then in the possession of Louis of Bavaria or his heirs. To mark this coronation, the high middle bow was added. Stylistically, the crown has its closest parallel to the one in Prague's St. Vitus Cathedral belonging to St. Wenceslaus and commissioned by Charles IV. As in the crown in Prague which decorated the reliquary of St. Wenceslaus and was used during coronations, the Aachen crown was kept with the Bust of Charlemagne. In the year 1414, King Sigismund was crowned with it in Aachen.

The use of ancient gems and cameos upon both the reliquary and the crown indicates a reference to Roman Antiquity. This reference was of great importance to the medieval imperial concept. By means of visible symbols in architecture, arts and crafts, and coinage which followed the tradition of Antiquity, the claim to the succession of the imperator Augustus became manifest in the Carolingian, Ottonian, and Hohenstaufen dynasties. This tradition was taken up again by Charles IV. HL

Reliquary of Charlemagne

- Aachen, mid-14th century
- Silver, hammered, cast, mostly gilt, with pearls, precious stones, and translucent enamel
- H. 125 cm, W. 72 cm, D. 37 cm
- Restored in 1978 in the restoration workshop of the Bavarian National Museum

Upon the inscription of the base supported by lions, the reliquary is called a "feretrum" or reliquary hutch. Listed in order of importance, it contains the following Passion relics: fragments of the Crucifixion nail, the crown of thorns, the Crucifixion cross and the sponge. These relics are carried by Christ and the statuettes of angels in the three turrets upon

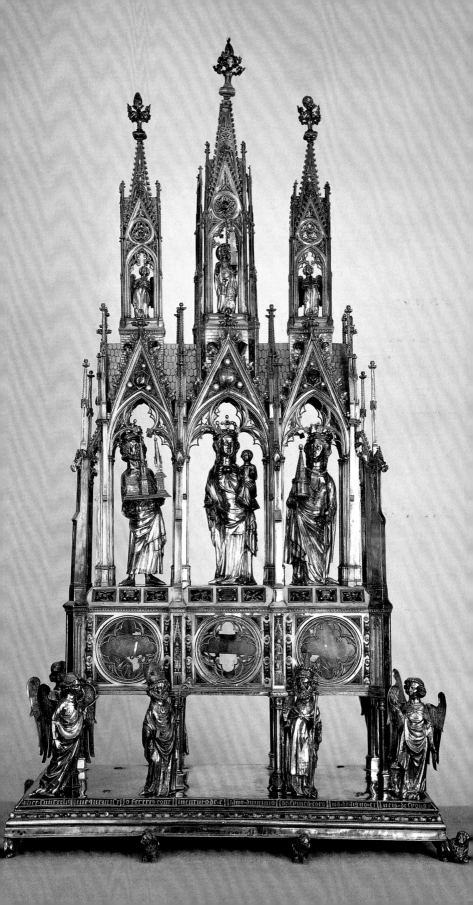

the reliquary's roof. Additionally listed are the arm bone of Charlemagne (which is in fact, a leg bone), three of Charlemagne's teeth and additional bone particles, as well as hair from St. John the Baptist, dust from St. John the Evangelist, an arm relic of St. Nicholas, and a tooth of St. Catherine. These relics, apart from the leg bone and Catherine relics, are contained in a small relic chamber in the roof.

The Passion relics were the first to be mentioned in the list. They occupy the most important position which is above the visible relic of Charlemagne. No inscription or coat of arms indicates the donor of the reliquary, but the choice of relics implies that its commissioner was Emperor Charles IV. The cult of the Passion relics and the cult of Charlemagne were closely connected with the Empire of Charles IV. In 1350, he came into possession of the imperial treasure, of which the Passion relics were a part. One year earlier, he had received from the coronation church at Aachen the same number of tooth relics which are kept in the Charlemagne reliquary. The relics of St. Catherine may have come from Charles IV, for she had been his patron saint since his victory in the battle of San Felice on St. Catherine's Day.

The reliquary, in the form of a three-steepled chapel, is supported by eight columns. In front of them, four angels and four figures from the legend of Charlemagne are positioned as carriers of the reliquary: Pope Leo III, Archbishop Turpin of Reims, and the paladins Roland and Olivier. The main reliquary is supported by two kneeling angels who can be seen through the round windows made of rock crystal. The main figures of the chapel reliquary are Charlemagne with an architectural model of the Aachen Cathedral, the Virgin Mary with the infant Jesus, and St. Catherine, who holds a reliquary in her hands. Three smaller towers crowned with peaked spires and finials accommodate Christ and two angels with the Passion relics.

The form of the Charlemagne reliquary signals the progression from a medieval reliquary shrine in which the relics are concealed. Here, in contrast, the three glazed round windows allow for a view of the relics. The use of the round windows revisits a tradition established by Emperor Constantine the Great, namely, that the grave of Christ which he discovered had featured three round openings. This holy grave type found numerous imitations during the Middle Ages. The construction and type of the Charlemagne reliquary is derived from 14th-century southern French and Italian grave monuments. Above the horizontally-positioned sarcophagus looms a monumental structure with three architectonic niches and richly-articulated roof architecture. The Charlemagne reliquary borrows elements from large-scale architecture such as gargoyles, pinnacles, and finials and implements them in miniature into the gold work. The stylistic precursor for the figures is located within Northern French sculpture of the late 13th-and early 14th centuries. HL

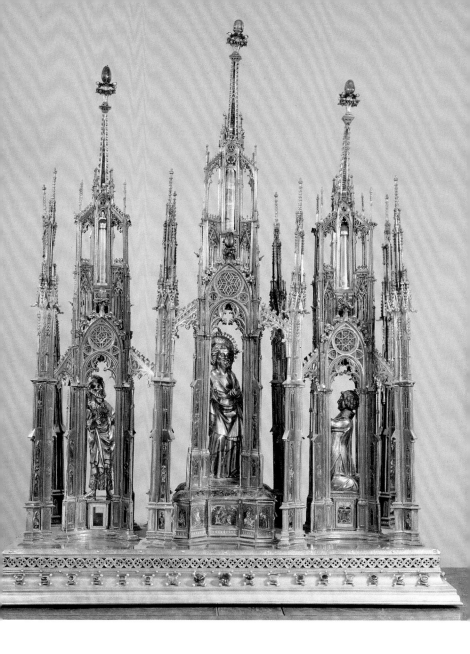

Three-Steepled Reliquary

- Aachen, around 1370/90
- Silver, hammered, cast, gilt, precious stones, translucent enamel
- H. 93.5 cm, W. 74 cm, D. 38.2 cm
- Restored in 1829 by the goldsmith F. A. Cremer
- Restored in 1978 by the restoration workshop of the Schnütgen-Museum in Cologne

Constructed in the manner of Gothic large-scale architecture, three steeples create niches for three small statues: John the Baptist, Christ, and a kneeling donor clad in the robes of a subdeacon. In the upper stories, three rock crystal cylinders filled with relics are integrated into the architecture. Scrolls within the containers designate the relics as pieces

of the sudarium of Christ, the reed Christ carried as a scepter as he was mocked, a rib from St. Stephen, and a tuft of hair from John the Baptist. All of the relics, with the exception of the reed, were already authenticated before the reliquary was constructed. The towers with their delicate tracery, the rose window, and the Gothic vaulting are crowned with finials featuring large sapphires. At the base, enamel plate fragments display scenes from the Life of Christ. Affixed to the buttresses are enamel representations of the apostles, prophets, martyrs, and virgins. The keystone of the vault above the Christ figure is shaped by the Lamb of God, as if forming the key to the reliquary's significance. In Revelations, St. John's description of the heavenly city reads: "And the building of the wall of it was jasper; and the city was pure gold, like unto clear glass ... for the Lord God Almighty and the Lamb are the temple of it. And the city had no need of the sun, neither of the moon, to shine on it: for the glory of God did lighten it, and the Lamb is the light thereof."

Examples of Gothic interior architecture with multiple steeples adjoining one another include the baldachin crownings of the papal graves of John XXII († 1334) and Innocent VI († 1361) in Avignon and Villeneuve-les-Avignon, as well as the coronation of the martyr's altar of the Carthusians in Champmol (in the Musée des Beaux-Arts in Dijon/Burgund). Between 1391 and 1399, the latter was made in Flanders as a copy of earlier altars no longer in existence. Knowledge of the Reims Cathedral's western facade is needed to understand the reliquary's figurative decoration. The varying, careful execution of various details of tracery and the tracery rosettes, as well as the fusion of more conservative with contemporary forms, suggest that several workshops or goldsmiths worked on this reliquary. In terms of its tripartite division, the reliquary belongs to the typological milieu of the Reliquary of Charlemagne and as its near-complement as a large chapel reliquary, is positioned opposite it.

HL

The Liturgy

To mark the celebratory masses in the Cathedral, sumptuous liturgical objects and implements were created. Through their radiance and beauty, gem-encrusted processional crosses, chalices, monstrances, choir robe brooches, and candlesticks symbolized the glory of God. Large altarpieces which were positioned over altars revealed the stories of the saints and enabled the events of the New Testament to become reality.

HL

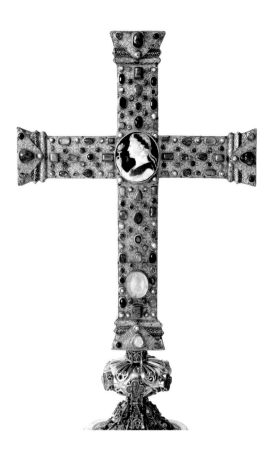

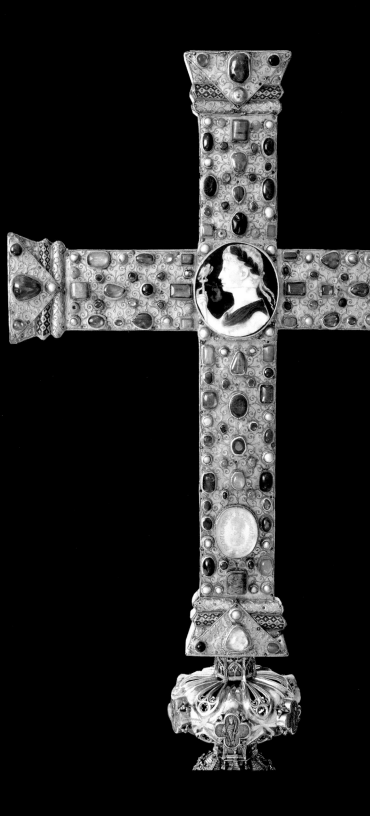

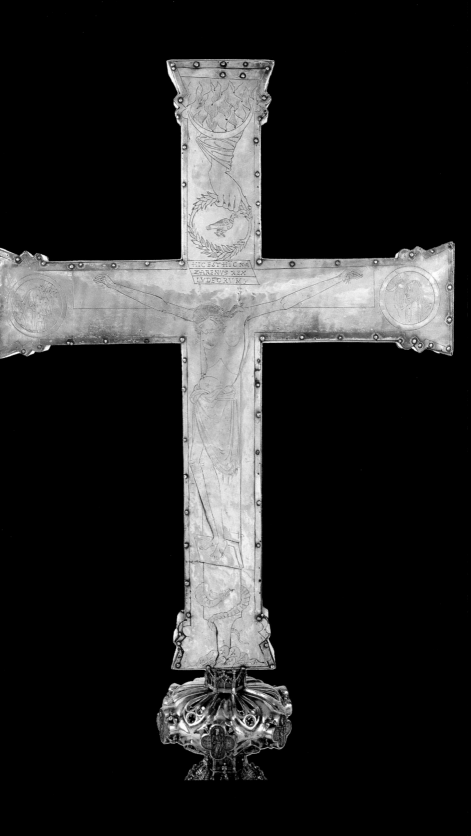

The Cross of Lothair

- West German (Cologne?), about 1000
- Late Gothic base
- H. 50 cm without Late Gothic base, W. 38.5 cm, D. 2.3 cm
- Gold, gilt silver, filigree, precious stones, ancient stone cuttings, and pearls upon a restored wooden core
- Ancient Roman sardonyx with the image of Emperor Augustus (L. 8 cm, W. 7 cm), engraved rock crystal (intaglio) of King Lothair
- Restored in 1815/16 and 1932; some stone mountings exist from the 1815/1816 restoration

The "Augustus side" as it is called, is decorated with precious gems, cut stones, pearls, as well as filigree work. Two stones are emphasized due to their images and dimensions: the three-layered sardonyx at the intersection of the cross, rendered as a (raised) cameo with the image of the laurel-crowned Emperor Augustus, and, affixed at the lower half of the vertical crossbar, a rock crystal portrait which gave the cross its name. Upon the signet stone, the inscription (in mirror writing) which accompanies the image of King Lothair (855-869) reads: XPE ADIVVA HLOTARIUM REG (Christ help King Lothar). The large jewels of the central axis appear like temples upon arcades and point to the symbol of the jeweled cross: the heavenly Jerusalem. The commission of a Christian cross with an emperor from Antiquity by a Christian emperor of the Middle Ages (probably Otto III), signals the celebration of the Christian emperor. At the same time, the ruler from Antiquity is compared to Christ, for on the engraved "Christ side" of the cross, Christ is shown in the moment of death. His head, which is at the same level as that of Emperor Augustus, bows to the side in death. The embodiments of the sun and moon at the ends of the horizontal bar bend their heads in sorrow. Above Christ, the hand of God holds the victory laurel, which is taken by the dove, the symbol of Christ's soul. The victory laurel corresponds to the laurel wreath of the Roman emperors. The snake coils itself around the base of the cross, symbolizing the defeat of evil. The entire cosmos is represented here: the sun wears a robe of stars, the bar of the cross grows from the Tree of Life, which in turn emerges forth from a mound of earth, and the flames of fire are received by the arc of heaven. The cross is an allegory for the grand concept of Emperor Otto III, that of the "renovatio imperii Romanorum," (renewal of the Roman Empire). Stylistically, the cross is similar to the first surviving large cross from the Middle Ages, the Ottonian Crucifix of Gero in the Cologne Cathedral, as well as to Ottonian book illumination of the Cologne School. Such similarities lead to the assumption that the cross originated in a workshop within Cologne. The Cross of Lothair presumably served as a processional cross during the coronations in Aachen, just as it is still used at celebratory processionals for the modern-day Mass.

HL

Golden Antepedium, Pala d'Oro (Cathedral)

- West German, about 1020
- 17 gold plate reliefs with repoussé work
- H. (total) 82 cm, W. 125 cm
- As an altarpiece, the Pala d'Oro constitutes the center of the altar apse of the Gothic choir cathedral; it was placed within a wooden frame and reinstalled as an antependium in 1951. The Pala d'Oro was stabilized and restored between 2000 and 2002 in the goldsmith's workshop of the Aachen Cathedral (Karlsverein-Dom-bauverein, vol. 5, 2002).

The main altar of the Aachen Cathedral is decorated by a golden antepedium: the early 11th-century Pala d'Oro. In the center of the antepedium, which consists of seventeen individual panels, Christ the Redeemer is enthroned, accompanied by the Virgin Mary, his mother, the Archangel Michael and the four symbols of the Evangelists. Grouped around this central image, ten relief panels with scenes from the Passion of Christ, beginning with the Entry Into Jerusalem and ending with the Women at

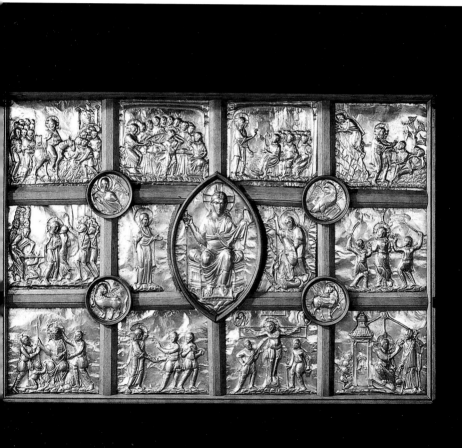

the Tomb. The history of the Pala d'Oro remains obscure. Presumably, it can be traced back to a donation in 1000 by Emperor Otto III, but was evidently completed under his successor, Emperor Henry II. Within the context of these large imperial donations are additional treasures which have been preserved in the Aachen Cathedral Treasury: the Cross of Lothair, the Golden Book Cover, whose scenes of the Crucifixion and Resurrection reoccur (in reverse) in the Pala d'Oro, the Ottonian Book of Gospels, the Ivory Situla, and the golden Gospel Pulpit of Emperor Henry II. Together with the twelve apostle reliefs of the Aachen Cathedral Treasury and altar panels with scenes from the life of Mary, the Pala d'Oro constitutes a large altar arrangement in the Gothic choir hall. Only in 1794, as French troops approached the city of Aachen, was it dismantled.

The Pala d'Oro is not stylistically cohesive. The first five reliefs, distinct in their clear fondness of narrative and vivacity, appear to have been created by a goldsmith native to and schooled in the Rhine region. By contrast, the remaining reliefs – together with the middle group of Christ, the Virgin Mary, and Michael – lean toward Byzantine and above all, late Carolingian examples, which provided the visual as well as textual foundation for Ottonian court art of the early 11th century.

The scenes of the Passion of Christ can be read like an illustrated book, from left to right. The Pala d'Oro appears to be a type of precedent for the numerous carved and painted altars of the Medieval and Late Medieval era. These altars were intended to convey the history of salvation to the faithful, who for the most part, could not read.

HL

Pulpit of King Henry II – Ambo (Cathedral)

- West German, between 1002 and 1024 (coronation of Henry II., 1024 death of Henry II).
- Ivory reliefs Byzantine and Alexandrian/Egyptian, 6th century
- Copper plate, hammered and gilt, brown varnish plates, precious stones, agate and rock crystal vessels, agate and chalcedon chess figures; oak parapet
- H. 146 cm, W. 115 cm
- Restorations undertaken in 1815–1817 and 1926–1937. Also restored in 2002 and 2003 in the goldsmith's workshop in the Aachen Cathedral. During the restoration from 1926–1937, three panels of the Evangelists no longer in existence as well as all but one of the original jeweled strips were reproduced.

The dedication inscription "Rex Heinricus pius" along the upper and lower edges of the pulpit names King Henry II as the donor of the ambo. The layout of the pulpit assumes a cloverleaf or trefoil shape. The middle portion of the pulpit is divided into nine sections. Four of them are filled with hammered copper plates depicting the four Evangelists. Only the panel with Matthew (upper left) has survived in the original. The remaining three panels were redesigned accordingly. The Evangelist sits in front of his desk; before him lays the open book with the beginning of the Gospel according to Matthew. The arrangement of the remaining five pictorial fields constitute a Greek cross. They are decorated with brown varnish plates, a green Roman drinking bowl (which

was later added), a cup and saucer made of rock crystal, as well as two agate bowls (the lower one was added in 1937). It is possible that the "Eagle Cameo," a Roman stone cutting from 27 B.C. (Vienna, Kunsthistorisches Museum) decorated the middle of this cross. As a symbol of God-given victory, the cameo would have reinterpreted the jeweled cross (crux gemmata) as the invincible cross (crux invicta). Compare, too, the victory eagle upon the Augustus cameo of the Cross of Lothair. The drinking vessels are framed by the agate and chalcedon chess figures. Jeweled borders, filigree work, and stamped

bands circumscribe the panels. Alexandrian ivory reliefs from the 6th century are affixed to both side extensions of the pulpit. The vine-clad, Greek God Dionysus is displayed twice at the lower left and right. Above him (left), nereids ride upon sea creatures; at the top left and right, a warrior on horseback (possibly an imperator) and a standing warrior are crowned by geniuses. The most impressive and high-quality of the six reliefs is a Byzantine work (on the middle right) of the goddess Tyche, the personification of power, navigation, luck, and catastrophe. She appears together with a maenad, who dances tensely and frenetically to the sounds of the wind harp and the flute of the goat-limbed god Pan (Lepie/Münchow, Elfenbeinkunst aus dem Aachener Domschatz).

Until the completion of the Gothic choir in 1414, the pulpit was located within the Palatine Chapel (most likely between the two south pillars), and ever since then, at the south wall of the first choir bay.

The term "ambo" is derived from the Greek word "anabainein" – to ascend. The ambo is elevated, accessible by way of a staircase. This ascent is explained in the words of the prophet Isaiah: "O Zion, that bringest good tiding, get thee up into the high mountain" (Isaiah 40:9). Using the staircase, one climbs up to the elevated ambo, in order to proclaim to the people the joyful message: the coming of the Redeemer. HL

Barbarossa Chandelier (Cathedral)

- Aachen, about 1165/1170
- Copper, engraved and gilt
- Original iron ring with supporting frame and ironwork chain
- Diameter ca. 4.16 m
- The silver relief decorations of the towers were lost in the 18th /19th century. The chandelier was stabilized and refurbished from 1990 to 1998 in the goldsmith's workshop of the Aachen Cathedral (Lepie/Schmitt, Der Barbarossaleuchter im Dom zu Aachen).

As noted in the inscription upon the Barbarossa Chandelier, it was donated by Emperor Frederick I and his wife Beatrix to the Mother of God, the patroness of the Aachen Cathedral. It is an image of the heavenly city Jerusalem, as seen in St. John's vision (Revelations 21). With regard to its form with eight arches and sixteen towers, as well as its numbers and dimensions (its diameter is equal to one quarter of the diameter of the Palatine Chapel), the chandelier was meant to dovetail with the architecture of the building for which it was donated. The sixteen towers bear engraved base plates with images directed towards the viewer beneath them. The round panels of the small towers reveal scenes from the life of Jesus: Annunciation, Birth, Adoration of the Magi, Crucifixion, Women at the Tomb, Ascension, Pentecost, and Christ in Majesty. The four square and four quatrefoil perforated plates of the large towers display the personification of the eight beatitudes of the Sermon on the Mount (Matthew 5:3-10). To the faithful who gaze towards the chandelier, these depictions indicate the path to the heavenly Jerusalem through the life and teachings of Jesus. 48 candles adorn the upper wall wreath. The significance of the number 48 resides in the litany of the twelve apostles, twelve martyrs, twelve confessors, and

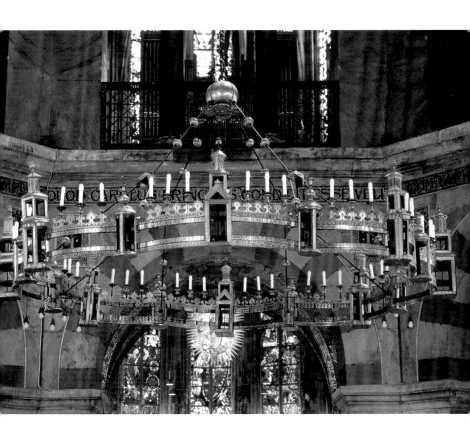

twelve virgins. It is sung during the anointment and coronation rituals of the Roman king for the feast day of the Epiphany at the Cathedral's Altar of the Virgin. Presumably, their images adorned 48 of the lost silver reliefs in the towers.

The style of the engravings, which were definitely made in Aachen by various masters, draws from book illumination and goldsmith work in Liège and its surroundings. For comparison, see the Liège Sacramentary that was made before 1164 in the library of the Cologne Cathedral. A 13th-century necrologium of the Aachen Collegiate Church mentions a master Wilbertus, who devoted "the greatest effort and work to the chandelier and the roof of the entire Church, a gilt tower cross and bells" and in doing so, "accomplished everything splendidly." Whether he was actually in-

volved with the chandelier's design and its engravings or supervised its installation and the enormous technical effort that came with it, cannot be determined. With its diameter of 4.16 meters, the chandelier does not fit through any of the Cathedral's doors. As a result, it was assembled and riveted in the Palatine Chapel in the 12th century.

Chronologically speaking, the Barbarossa Chandelier is the last in a series of four preserved medieval chandeliers, the others consisting of the Hezilo and Azzelin chandeliers in Hildesheim and the chandelier in Comburg. From the Middle Ages, 34 additional chandeliers have survived in the large collegiate churches in Goslar, Cologne, Cracow, Mainz, Metz, Speyer, Trier, Prague, Paris, Cluny, Bayeux, Reims, Monte Cassino, and Canterbury, among others.

HL

Christic Within a Mandorla

- Meuse region, circa 1180
- Converted into choir brooch with the addition of the Evangelists' symbols and filigree work
- Gilt copper and champlevé enamel
- H. 13.3 cm, W. 11 cm
- Possibly the middle section of a Hohenstaufen book cover

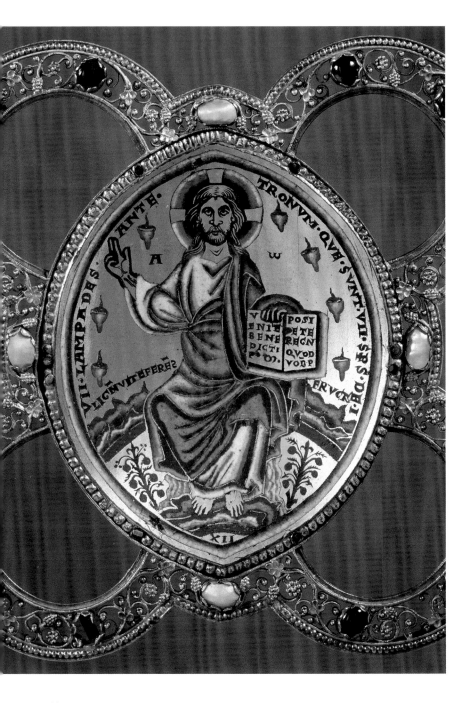

Christ is enthroned upon a rainbow within a mandorla between the symbols of alpha and omega; these symbolize the beginning and the end of creation. He raises His right hand in blessing, while with the left, he holds the opened book with the words according to Matthew (Matt. 25:34): "VENITE BENEDICTI P(ATRIS) M(EI) POS(S) DETE REGN(UM) QUOD VOB(IS) P(ARATUM EST). Come, ye blessed of my Father, inherit the kingdom prepared for you." Seven lamps along the sides (of Christ) are shown with the inscription: "VENITE BENEDICTI P(ATRIS) M(EI) POS(S) DETE REGN(UM) QUOD VOB(IS) P(ARATUM EST). Seven lamps before the throne, which are the seven spirits of God." Two branches, bearing twelve red fruits are illustrated via the inscription over the rainbow: "LIGN(UM) VITE FERE(N)S FRUCT(US) XII. The Tree of Life, which bears twelve fruits." HL

Ivory Panel

- Meuse region, about 1100
- Ivory
- H. 20.1 cm, W. 11.5 cm
- Private donation from Aachen, 1873

The vertically-aligned rectangular panel is divided into three deep-set, horizontally-aligned rectangular fields set one above the other. They are framed by borders and in some areas, by additional beaded ornamentation. From bottom to top and accentuated along the vertical axis by the Virgin Mary's right hand, are the manger, the baptisand, and the cross. These illustrate the Birth of Christ, the Baptism of Christ in Jordan and the Crucifixion as the tripartite manifestation of the Son of God.

Two shepherds listen to the message of the angel. The contours of a cave-like dwelling curve over the bed of the Mother of God, who raises her hand in prayer, as well as the manger with the newborn and ox and ass. Aloof and at a distance, his head averted, a sleeping St. Joseph is seated at the right. An angel above him points out the events of the scene.

At the Baptism of Christ in Jordan by John the Baptist, the Holy Spirit descends from Heaven over His head. From both sides, angels with large cloths make their way towards Him to clad the standing baptisand before the mountain of waves.

At the Crucifixion, a chalice at Christ's feet indicates the Eucharistic symbolism of the event. Beneath the cross and on either side stand the mournful figures of the Virgin Mary and John. The sun and moon and two rose-like clouds, together with the geometric construction of the scene, which is based upon the number four, underscore the cosmic significance of the event. The symbols of the Evangelists occupy the corner pendentives.

The chalice at Christ's feet, as well as the four nail holes in the corners of the panel, indicate that it was probably used to cover a liturgical book. The relationship of this panel to the main relics of the Aachen Cathedral – the robe worn by the Mother of God at the Birth of Christ, the diaper, the circumcision cloth of John, and Christ's loincloth – is a remarkable one., for although the relics were in Aachen at the time of this panel's creation, they were not specifically acknowledged.

The division of the panel into three parts, its format, and its narrative sequence from bottom to top calls to mind the works of the Court School of Charlemagne (see its diptych for comparison). However, along with the decisive influence of the Late Carolingian School from Metz, a work of

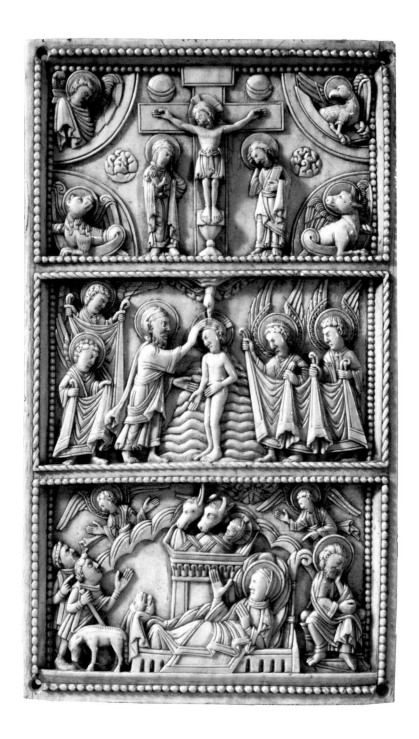

about 900 from the School of Tournai seems to have served as a template for the panel. The Byzantine influence is noticeable in the cave where Christ was born. The panel falls easily within the group of Late Carolingian Meuse ivories from the 1100s. The Simeon's panel in Trier and two panels with the Birth and the Crucifixion in London provide opportunity for comparison. GM

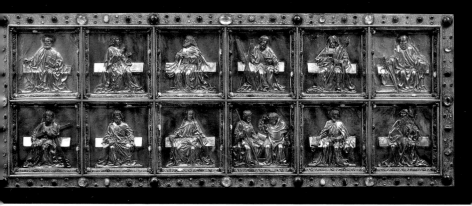

Apostle Antependium

- Aachen, about 1481
- Hammered silver, gilt, with two panels (Peter and Paul) in hammered gold
- Reliefs: H. 25 cm, W. 25 cm
- 20th-century framing

Together with the Pala d´Oro, the antependium altar forms the altarpiece decoration in the Gothic choir hall of the Cathedral. Ten of the twelve panels are stylistically cohesive. The apostles sit together, sometimes turned toward one another, upon unadorned benches; they are distinctive by way of their attributes. A thirteenth figure, whose attire suggests a canon, is most likely the donor of the antependium. The canon is is striking on account of his attire and a contemporary attribute, foldable spectacles, which he holds before his eyes.

The relief panels with scenes of the Apostles Peter and Paul (seen in the upper row on the left and right) deviate from the remaining relief in terms of their technical form and style. They are more flatly rendered and less sculptural and organic.

HL

Passion Altar, so-called Aachen Altar

- Cologne, about 1515/1520, so-called Master of the Aachen Altar
- Oil on oak
- H. 143 cm, middle panel W. 242 cm, wings W. 114 cm

On the opened altar, from left to right are 16th century scenes which mirror the Passion of Christ until the Ascension. On the left wing is the Coronation with the crown of thorns and Christ before Pilate; in the middle is the Carrying of the Cross with the Crucifixion as the central scene,

Christ's Descent into Limbo, and the Death of Judas; on the right-hand wing is the Lamentation, the Entombment, the Resurrection, the meeting with Mary Magdalene, and the Ascension of Christ. Using the distribution of red pigments, the painter achieves a progressive rhythm across the panels and wings corresponding the progression of the events.

With the exception of Christ, the Mother of God, and John, the figures are clothed in contemporary clothing within a regional landscape. By doing so, the Biblical events, in which the viewer is intended to envision himself, become relevant. Moreover, the division of the central panel from the cross, at which "the spirits divide" into positive and negative images at the right and left of Christ, elicits the viewer's response by way of the gazes beyond the field of representation, as do the pointed gestures towards the events taking place within the panel.

On the left is a soldier of Turkish origin, who, clothed in martial attire and curved sword, leads Christ to Pilate. This characterization is based upon the Turkish threat at the time of the altarpiece's execution. At the same time, a mongoloid boy is groomed by a monkey, which alludes to the demonic obsession of the demanding bystanders who called for the death of Christ. The delicate head of the boy with the dark beret is thought to be a self-portrait of the painter.

The church with the unfinished towers in the background has perhaps been mistakenly interpreted as the Cologne Cathedral; in the alley before it, the Schildergasse as well as the Three King's Gate of St. Maria in Kapitol in Cologne. The church facade visible behind one of the columns has been identified as that of the Cologne Carmelite Church.

The wing exteriors reveal six saints standing in front of a brocade curtain. On the left wing are seen the Carmelite saint Anthony of Hungary, St. Barbara, and St. Sebastian. On the right wing are St. Lawrence, St. Catherine, and the Carmelite saint, Angelus. They are displayed beneath framing elevated arcades with a view towards the treetops, with the significance of the Carmelite saints particularly highlighted via church towers.

Until 1642, the winged altar was located at the cross altar of the Cologne Carmelite Church. From 1761 until 1834, it was in the Lyversberg collection in Cologne. From 1834 until 1872 it was with Cologne's Haan collection and was acquired for the Collegiate Church of Aachen in 1872. Since then, the altar has stood in the choir hall of the Cathedral.

The unknown artist, tentatively identified with the Cologne copper engraver P.W., was named after this principal work as the Master of the Aachen Altar. He was known to have painted in Cologne between 1480 and circa 1520. His art is the result of the kinship with the older Master of the Holy Family, the Master of the Ursula Legend, his contemporary the Master of St. Severin, as well as with the clothing style of 16th-century Cologne. Still, alongside the strong influences of the Middle Rhine in terms of its technical execution, Netherlandish and Mannerist tendencies from Antwerp manifest themselves as well. Of particular interest is the artist's noticeable interest in medicine, as evidenced by the representations of the mongoloid child, the blind captain, or the rider afflicted with syphilis.

Exactly when the altarpiece was commissioned is unknown. The donor, whose name was Theodericus de Gouda and was the provincial superior of the Carmelite Cloister in Cologne, died in 1539. New evidence towards the work's date of completion may be offered by the recently-discovered fact that his head was painted over by the artist and the altar was not completed (the black horse to the right of the central panel). The Cologne clothing styles within the panel correspond to the years between 1495 and about 1500. GM

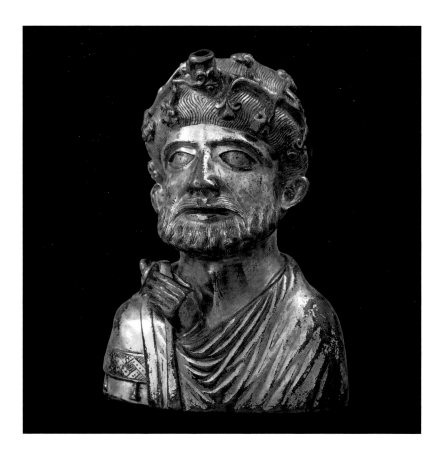

Pouring Vessel (Aquamanile)

- Aachen, about 1170/80
- Cast and gilt hollow bronze
- H. 18.3 cm

During the 12th and 13th centuries, bronze pouring vessels were made in the Rhine-Meus region. These were used as liturgical vessels for hand-washing during the Holy Mass. The diversity of forms (heads, animals, centaurs, horsemen and horses) suggests that the vessels also served a non-religious purpose.

The small half-figure is clothed in an ancient robe. At the base of the throat, the left hand extends out from beneath the robe. The face of the small figure stiffly faces forward. The wide chin is covered by a short, grizzly beard, with a wide mustache running across the sharply-angled lips. The profile is accentuated and the voluminous hair extends deeply towards the forehead. Between two vine tendrils above the forehead, the pouring spout can be seen. The figurine's designation as Bacchus is owed to the vine leaves wrapped around its head and is derived from ancient portrait busts of rulers. From a stylistic angle, the vessel belongs to the circle of Alexander heads in Stavelot and the Brussels relics of the saints Monulphus and Gondulphus. The engraved ornamental band on the right upper arm can be compared to the ornamentation of the Barbarossa Chandelier.　　　HL

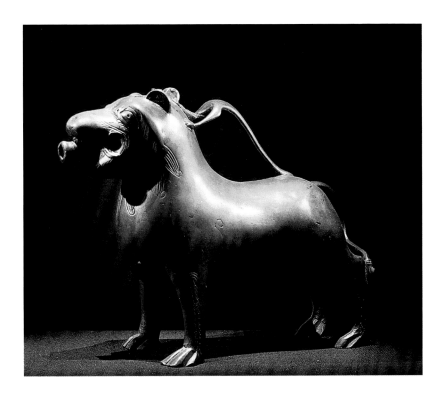

Lion (Aquamanile)

- Rhine-Meuse region, circa 1170/80
- Cast hollow bronze
- H. 21 cm, W. 27.5 cm, D. 10 cm

The body of the lion features a smooth contour and spare, stylized modeling. A pouring spout extends from its open mouth. The head of a chimera-like creature is attached as a handle along the lion's back. It terminates at the lion's head as a hinged lid for replenishing water.

HL

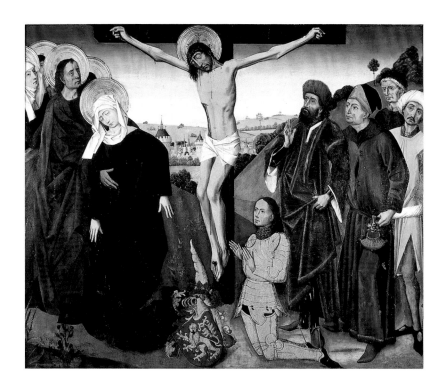

Crucifixion Altar, so-called Saynscher Altar

- Cologne, around 1460
- Master of the Legend of Gregory
- Oil on oak
- H. 116 cm, W. 136 cm

The crucified Christ is portrayed in front of a vast, hilly landscape, flanked by two groups of figures. To the right of Christ, the Mother of God leads the group of mourners. She is supported by John as she faints out of compassion for Christ. Four men stand to the right, with the first two dressed in contemporary attire. They meditate, a gesture which has been adapted from corresponding images from Italy. The viewer of the altar is meant to follow suit through the word of the leading figure, who points to Christ: "Truly, here was the Son of God." The donor of the altar panel, an earl of Sayn, kneels in golden armor beneath the cross with his coat of arms in front of him.

The reverse of the panel, which was extensively painted over in the 19th century, shows the Madonna and Child upon a throne within painted architectural niches and flanked by Anthony the Hermit and Francis. Upon the throne steps, the donor kneels again; the infant Jesus touches his praying hands.

The double-sided altar panel was originally located at the cross altar upon the gallery of the choir hall's so-called Marian small choir, later at the south altar of the choir hall. Despite its multifaceted influences from the art of Roger van der Weyden, the altar panel closely follows a Crucifixion image from the Master of the Life of the Virgin Mary in Cologne.

GM

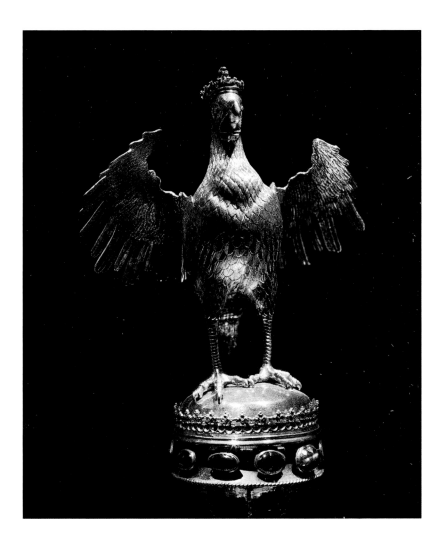

Crown of a Cantor's Staff

- Eagle, Aachen, around 1470; hexagonal knob with cap around 1420
- Silver gilt and cast, set with precious stones

The cantor's (or precentor's) staff was carried by the chief singer of the choir, the cantor on Sundays and feast days. Countless cantor staffs of this type are mentioned among medieval church inventories; however, only a few have survived. The Aachen example resurrects of the tradition of the imperial eagle.

HL

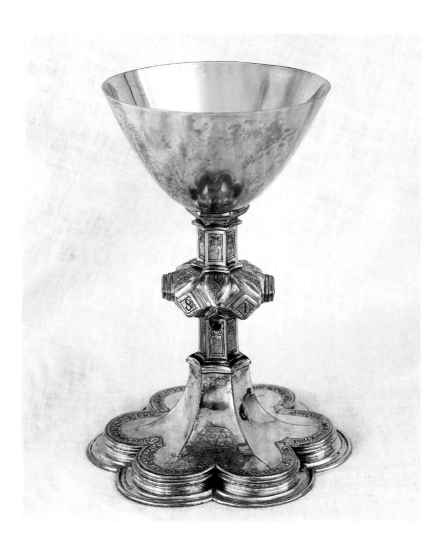

Chalice

- Aachen, early 16th century.
- Marked with the master seal of the Aachen goldsmith Hans von Reutlingen and the Aachen city inspector
- Hammered and gilt silver
- H. 18 cm

The Latin inscription upon the chalice base refers to the donor, Johannes Pollart. He was canon of the Aachen Church of St. Mary who donated this chalice in 1528 to be used at the daily Mass. The limited decoration of the chalice is restricted to the engraved cross at the chalice base and the stem with the richly-articulated node. The name JHESUS is displayed upon the diamond-shaped surfaces.

HL

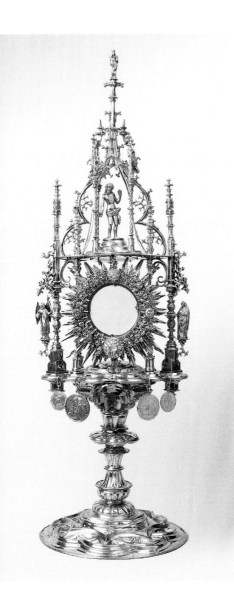

Monstrance

- Aachen, about 1520
- Marked with the master seal of the Aachen goldsmith Hans von Reutlingen and the Aachen city inspector
- Hammered silver, cast and gilt
- H. 59.5 cm
- The diamond wreath that was added during the Baroque era was supplemented with additional diamonds in 1842.

The monstrance is thought to have been a gift from Emperor Charles V, who was crowned king in 1520 in Aachen. It originally featured a glass cylinder of the Gothic tradition, in which the transformed bread of the Eucharist was kept. During the Baroque era, the glass cylinder was removed and replaced with a diamond wreath indicating the sun. Virtually no other work by Hans von Reutlingen displays the Late Gothic details as expressively as this monstrance. Gothic, stiff forms dissolve into spacious, layered arabesques. While vertical elements take precedence, they are resolved by the wide, multi-layered base, the foundation and base plate, as well as the leafy arabesques, in which Christ appears as the Man of Sorrows.

HL

Reliquary, Agnus Dei

- Aachen, around 1515
- Marked with the master seal of the Aachen goldsmith Hans von Reutlingen and the Aachen city inspector
- Hammered silver, cast and gilt
- H. 40.5 cm
- The medallions with the lamb and the resurrected Christ are Italian works, which were donated to the Aachen Collegiate Church of St. Mary by Pope Eugene IV.
- Gilt silver, hammered, cast, and engraved

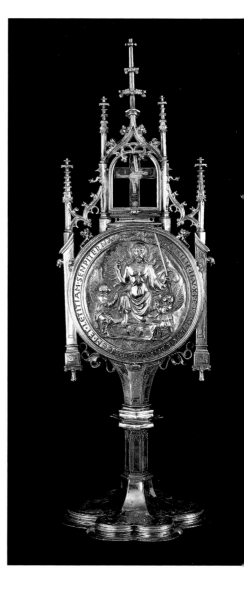

The reliquary is constructed in the manner of a small monstrance. The center incorporates the medallion with the Resurrection of Christ (front) and the Lamb of God (reverse). The translation of the Latin inscription reads: "Lamb of God, that you take away the sins, have mercy on me. Lord Jesus Christ, King and Glory, give us peace and everlasting joy." Above this, the visible relic is located. The form of the monstrance as a vessel for relics was widespread at the end of the Middle Ages. It allowed for a view of the relic, which was displayed behind a sheet of glass or rock crystal, and permitted the relic to become real and tangible. The capsule reliquary type was common in the late 15th and early 16th centuries.

Aside from a waxen Agnus Dei, the central reliquary capsule contains diverse relics with their relics: bone splinters from St. Nikolaus and St. Pantaleon. The most important relic, however, is a Marian relic. The canon Franz Bock reports that in 1804, precious items from the Cathedral Treasury were given to Empress Josephine, who visited there while in Aachen. Just before the gift-giving took place, one of the gifts from the Carolingian Talisman of Charlemagne was removed: the valuable relic of the hair of the Virgin Mary. This was stored in the Agnes Dei medallion. A cross relic was placed in the talisman and given with other precious tokens to the Empress. In this way, the Agnus Dei Reliquary maintains the memory of the Talisman of Charlemagne within the Aachen Cathedral Treasury. The talisman came via Empress Eugenia into the Treasury of the Reims Cathedral. HL

Choir Robe Brooch

- Aachen, before 1520
- Attributed to Hans von Reutlingen
- Hammered silver, cast and gilt; pearls and precious stones
- Diameter 16 cm
- The original metal sheet was converted into the brooch after 1865. By doing so, the trefoil was reshaped into an irregular quatrefoil. In the lower section, the coat of arms was added and the master seal was probably destroyed.

An irregular quatrefoil is placed inside a six-petaled rose. A series of columns with Late Gothic baldachin arches alludes to a room in which the Mother of God sits enthroned with Christ.

The kneeling donor is endorsed by his name saints, Mark and Anthony.

The goldsmith's models for the small figures and the Virgin Mary were located in the Netherlands and Brabant, respectively, and for the two saints, from carved altars from the Lower Rhine area.

HL

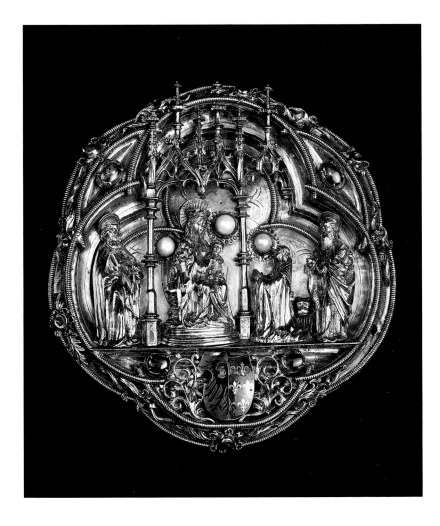

Two Seal String Knobs

- About 1500
- Hans von Reutlingen (?)
- Gilt silver hollow sphere, hammered and engraved, with three components
- Diameter 8.2 cm

- About 1528 (?)
- Hans von Reutlingen (?)
- Gilt silver hollow sphere, hammered and engraved, with two components
- Diameter 7.3 cm

The spheres serve as string capsules in which strong cords of twined silk thread were kept. These could be retrieved from an opening in the sphere to be used when sealing documents.

HL

Gregory's Mass

- Hildesheim, about 1525
- Oak shrine, lime or poplar sculptures
- Form mostly 19th century,
 with fragments of the original form
- H. 129 cm, W. 284 cm

In the central shrine of the winged altar is seen the panel known as the Mass of Gregory. According to a legend from as recently as the 14th century, Christ as the Man of Sorrows appears before Pope Gregory at the celebration of the Eucharist. Christ stands in a sarcophagus above the altar and points to the wound in His side. In doing so, the miracle verifies the real presence of Christ in the Eucharist. The kneeling pope is assisted by two deacons, while two bishops and two cardinals, one of whom holds the papal tiara, surround the altar. The inscription beneath the scene refers to an indulgence for prayers before images of this type, which were especially popular in the era of the Counter-Reformation.

Along the sides of the central field, a statuette of the Mother of God with Child stands on the left; on the right is the Virgin and Child with St. Anne. Shown beneath are the two patron saints of Hildesheim who are also the patron saints of physicians and apothecaries: St. Cosmas holds an ointment jar, St. Damian a bottle.

On the altar wings, the apostles with their attributes stand in two rows arranged atop one another. Only traces of paint remain from the earlier ornamental painting of the wing exterior.

The altarpiece was constructed for the altar of the Anna Chapel.

Closely related to this image is the Marian altarpiece of 1509 in Hetjershausen from the workshop of Bartold Kastrop.

GM

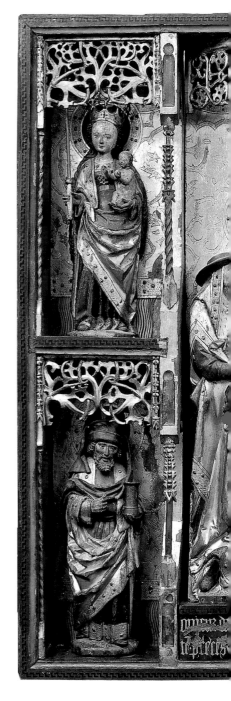

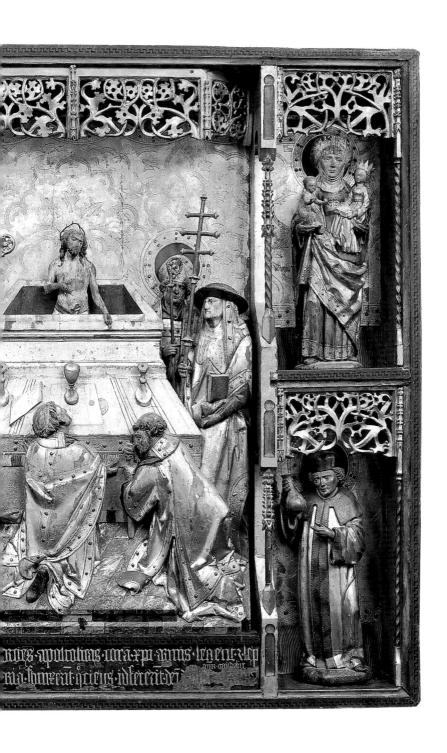

Coronations

The Aachen Cathedral is the coronation church of the German kings. From 936 to 1531, thirty kings and twelve queens were crowned here. Emperor Charles IV announced the second part of his kingdom's fundamental law of the Golden Bull in 1356. In it, the coronation in Aachen was declared and made mandatory. The coronation was carried out by the Cologne archbishop as consecrator and occasionally, by the Mainz archbishop. In the "Aquisgranum," which in 1620 constituted the first printed history of Aachen, the chronicler Petrus à Beek describes the coronation ceremonies:

"After the coronation, the king ascends the throne of Charlemagne in the high choir in prayer, after which he receives congratulations. The Te Deum is sung and the consecrator returns with his escort to the altar in order to end the Holy Mass, while the remaining electorates remain with the king. In the meantime, the king is received in the Aachen chapter and upon the old Book of Gospels, swears the oath of allegiance and obedience before the blood of the protomartyr Stephen. Then he accepts the knightly accolades with the Carolingian sword and descends into the Cathedral, where the formal Mass continues." HL

Kings and Queens Crowned in Aachen

7. August 936	Otto I the Great and Edith
26. May 961	Otto II
25. December 983	Otto III
14. April 1028	Henry III
17. July 1054	Henry IV
30. May 1087	Conrad of Lower Lorraine (Antiking)
6. January 1099	Henry V
13. September 1125	Lothar of Supplinburg
13. March 1138	Conrad III
30. March 1147	Henry
9. March 1152	Frederick I Barbarossa
15. August 1169	Henry VI
12. July 1198	Otto IV of Braunschweig
6. January 1205	Philip of Swabia and Irene
25. July 1215	Frederick II
8. May 1222	Henry (VII), Margaret 1227
1. November 1248	William, Count of Holland
17. May 1257	Richard of Cornwall and Sancia
24. October 1273	Rudolf I of Habsburg and Anna
24. June 1292	Adolf of Nassau and Imagina
24. August 1298	Albert I of Habsburg
6. January 1309	Henry VII, Duke of Luxemburg and Margaret
25. November 1314	Ludwig IV Bavarian and Beatrice
25. July 1349	Charles IV of Luxemburg and Anna of Palatinate Anna of Świdnica 1354
6. July 1376	Wenzel, King of Bohemia and Joanna
8. November 1414	Sigismund of Luxemburg and Barbara
17. June 1442	Frederick III
9. April 1486	Maximilian I
23. October 1520	Charles V
11. January 1531	Ferdinand I

Scepter

- England, circa 1220 or later
- Hammered and gilt silver
- H. 86 cm

The smooth staff, interrupted by a flat bulge at its lower half, is crowned by a dove. The staff is thought to have been the scepter of Richard of Cornwall, who was crowned King of Germany in Aachen in 1257. In 1262, he donated a golden crown, a gilt apple and a gilt scepter to the Aachen Collegiate Church. These regalia were intended to be used for future coronations in Aachen. It cannot be determined whether this staff was among the regalia donated by Richard. Nonetheless, English scepters typically featured a dove at its crown.

HL

Oath of the Roman King as Canon of the Collegiate Church

- Hammered and chased silver frame, about 1740, J.J. Couven (?)
- Parchment on oak
- H. 43 cm, W. 54 cm

"IURAMENTUM ROMANORUM REGIS. NOS N: DIVINA FAVENTE CLEMENTIA ROMANORUM REX HUIUS NOSTRAE ECCLESIAE B. MARIAE AQUENSIS CANONICUS Promittimus, et ad haec Sancta Dei Evangelia Iuramus eidem Ecclesiae fidelitatem, et quod Ipsam, Iura, Bona, et Personas eiusdem ab omnibus iniuriis et violentiis defensabimus, et faciemus defensari.– Eiusque Privilegia omnia et singula, et consuetudines ratificamus, approbamus et de novo confirmamus."

English translation: "The formulation of the oath of the Roman king. We, N. of God's grace and benevolence of the Roman King and of this, our Blessed Virgin Mary of the Aachen Collegiate Church, promise and vow loyalty to this Church on this, God's Holy Gospel. And we swear that we will have its rights, goods, and people defended from injustices and injuries, and that we will maintain, regard, and renew its valid customs individually and as a whole."

Following the coronation in the Aachen Cathedral, the King was accepted into the coronation chapter. He swore the oath of allegiance upon the imperial regalia kept in Aachen: the Bursa Reliquary of Saint Stephen, the Sword of Charlemagne, and the Coronation Book of Gospels. These three coronation regalia which had been kept in Aachen since the Middle Ages, along with the complete treasure, were taken away to the Capuchin cloister of Paderborn in August 1794 just before the French Revolutionary troops occupied Aachen. On October 15, 1798, they

were delivered under force to an imperial delegation from Vienna. Since then, they have been kept together with the remaining imperial regalia in the Secular Treasury in Vienna. The Oath, which was kept in Paderborn in the same crate as the Aachen imperial regalia, was not taken to Vienna. It returned with the Treasury to Aachen and is a final commemoration to the Aachen imperial regalia.

HL

Ottonian Book of Gospels (exhibited periodically)

- Reichenau, before 1000
- 256 parchment sheets
- H. 29.8 cm, W. 21.5 cm
- Part of a Roman silver book cover from 870 until 1972, newly bound in 1972

The manuscript contains the texts of the Four Gospels according to the Vulgate (Bible) of St. Jerome with the corresponding arguments (Preface), as well as a pericope index. They are written in Carolingian miniscule (cursive) script in a single-columned black ink; titles and headings appear in golden (upper case) capitals. The bordering numerals are also written in gold.

Numerous entries made at a later date report that the manuscript was probably donated in 1000 by Otto III to the coronation church in Aachen at the foundation of the king's canonry. For centuries, it served as the Book of Gospels on which the Roman-German kings (as canons) and all canons of the Aachen Collegiate Church took their oaths. After the French Revolution, the manuscript fell into private ownership and was reacquired in 1848.

Thirty-one complete illustrations (4 Gospel sheets, 4 initial pages; 21 images with scenes from the Life of Christ; a dedication page to the monk Liuthar with the apotheosis of Otto III located opposite) and twelve canon sheets adorn the manuscript. The 21 miniatures with scenes from the Life of Christ are sometimes placed in two registers one above the other and are all vertically aligned, which is a first in book illumination. Also unprecedented is the gold background, which frames the columned arcades crowned with capitals. Despite the small format, the figures within the scenes have a monumental impact. In keeping with Grimme's observation that "The reality of eternity defines its appearance," the Gospel Book's images are composed from Late Antiquity, Middle Byzantine and Trier works.

The double-sided, preface Gospel dedication page is of particular significance. On the left side within a quatrefoil placed on its edge, the monk Liuthar stands with the Book of Gospels in his hands. He looks to the ruler portrayed on the opposite page. Above and below this appears the dedication inscription, which is composed in hexameter with golden capitals upon a purple background. In English, it reads: "With this book, Emperor Otto, may God adorn your heart. Remember that you received it from Liuthar."

The image across from it is framed by a wide, Byzantine imperial crimson arcade. Within it and before a gold background, Emperor Otto III sits upon a throne supported by Terra, the personification of the earth. Otto is clothed in a tunic and cloak according to the Western Roman imperial style of Antiquity. He is enclosed by the pointed oval nim-

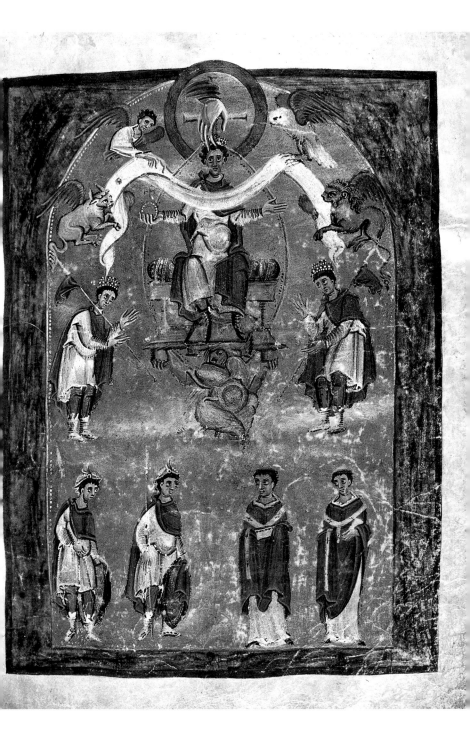

bus or mandorla that normally surrounds images of the enthroned Christ, thus becoming the anointed one through the act of Christ's coronation. Within a circular blue halo, the hand of God appears over the cross and crowns the emperor. Otto extends his arms in the manner of the crucified Christ, the

right hand holds the globus cruciger; the left hand is opened to receive the book from Liuthar. The four apocalyptic beings, as the symbols of the Evangelists, hold the white scroll of the Gospels across the chest of the emperor, thereby "adorning his heart." On both sides of the throne, two kings who pay homage are standing with flags which refer to their fiefdom. They are thought to be Boleslaw Chrobry and Saint Stephen, who was promoted to king by Otto in 1000. In the lower register, two dignitaries with helmets, lances, and shields approach, as well as two spiritual dignitaries, archbishops wearing the alb, chasuble, and pallium, with writing instruments.

This so-called apotheosis of Otto III is with regard to its Byzantine influence, a unique departure from the representation of Christ in Majesty. The emperor, whose heart is filled from the Gospel, appears as a figure crowned by God and supported by the earth. He is the representative of Christ to whom the world's powerful pay homage.

In 2004, the manuscript was included among the UNESCO "Memory of the World" register of 91 documents worldwide.

GM

Golden Book Cover

- West German (Rhine), around 1020
- Hammered gold, precious stones, five ancient gems and cloisonné work, ivory
- H. 30.3 cm, W. 24.3 cm
- Byzantine ivory, mid-10th century
- H. 13.4 cm, W. 12.7 cm
- This was the central portion of a folding or portable miniature altar, corresponding to two ivory panels of the Silver Book Cover. It may have belonged to an altar decoration of Emperor Henry II, like the Golden Altarpiece (Pala d'Oro) and the Cathedral Pulpit. Until 1972, it functioned as a book cover to the Carolingian Book of Gospels of the Aachen Cathedral Treasury, possibly replacing a Carolingian book cover.

The center of the vertically-aligned book cover is comprised of a Byzantine ivory panel with Mary and Christ. Mary personifies the Hodegetria, that of the one who shows the way; it is one of the five especially venerated image types of the Madonna. In a reverent gesture, she points to Christ the Redeemer. The name is derived from a Madonna image of the 5th century, which was particularly admired in the Cloister of the Leader of the Way in Byzantium. The ivory panel is thought to imitate this Byzantine image of the Madonna. Around the panel are arranged four scenes from the Life of Christ (Birth, Crucifixion, Women at the Tomb, and Ascension), as well as the four symbols of the Evangelists. At the same time, the horizontal and vertical strips of precious stones and cloisonné form a jeweled cross, whose central point is occupied by the ivory panel.

The outer frame is comprised of a broad jeweled border with beehive- and rhombus-shaped shaped filigree work, set in flat bands around the stones. In terms of style, the reliefs are closely related to those of the Golden Altarpiece and most likely originate from the same workshop, as the reliefs of the Crucifixion and the Women at the Tomb are shown there in mirror image. Regarding its proportions, the book cover follows the tradition of Carolingian book covers.

Compare this with the stylistically and chronologically similar work of the cover of the Codex Aureus of Echternach in Trier of circa 985-991 (Nuremberg, Germanisches Nationalmuseum).

The ivory panel probably comes from the bridal dowry of Empress Theophanu († 991), who came to the West from Byzantium in 972 to marry King Otto II. With the Rhenish gold work reliefs, the Byzantine Madonna image creates a synthesis of Eastern and Western art of the Ottonian period (Lepie/Münchow, Elfenbeinkunst). HL

Silver Book Cover

- Meuse area, around 1170/80
- Wooden core with hammered silver plate and ivory
- H. 30.8 cm, W. 23.7 cm
- Byzantine ivory, mid-10th century
- H. each 11 cm, W. 5.7 cm
- Until 1870, this book cover served as the reverse cover of the Carolingian Treasury Gospel Book; after that, it was attached as the frontal upon the Ottonian Gospel of the Aachen Cathedral Treasury. The cover has not been attached to the codex since 1978.

The book cover displays a vertical and horizontal division into disparate zones, a feature which has been carried over from the Carolingian Period. Two narrow ivory panels with the half-figures of the four saints John the Evangelist, John the Baptist, Theodore, and George occupy the middle of the silver cover. They are accompanied by two archangels on either side. On the upper and lower regions of the ivory panel, the Four Evangelists are portrayed within arched niches. Sitting at their writing desks, they listen to and take inspiration from their symbols. Like their significant predecessors found in the Carolingian Gospel Book of the Aachen Cathedral Treasury, the Evangelists are presented in four different stages of life in four different aspects of writing: writing, dipping the quill, reading, and meditating upon what has been written (John is at the upper right). Despite major restorative procedures and overpainting in the 19th century, the silver reliefs can be grouped stylistically with Meuse shrine sculpture of the late 12th century.

The two ivory panels belong to the iconographic design of the Hodegetria and along with the relief of the Golden Book Cover, form a hinged or portable altar. See also the Golden Book Cover (Lepie/Münchow, Elfenbeinkunst). HL

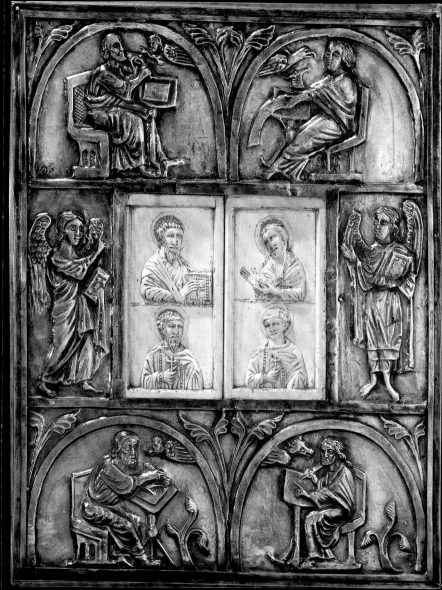

Ivory Situla

- Middle Rhine, around 1000 or 1020; or West German (Trier?) or Lorraine, about 1000 or later
- Ivory, jewel-encrusted metal bands
- Bronze handle and applied silver added in 1863 by the Aachen Cathedral goldsmith Martin Vogeno
- H. 17.5 cm, upper diameter 12.5 cm, lower diameter 9.5 cm

The two-leveled, octagonal, vertically-aligned vessel is cut in deep relief from an ivory tusk. The situla widens gradually from its base. In the lower area, armed guards wearing chain armor, cloaks, and helmets and armed with swords and shields, stand in front of city gates; seven are shown open while one remains closed. Above the gates appears a city in miniature form, which includes portico architecture beneath the seated king. Of the outdoor space before the city gates, an interior is assigned to the upper area. Five standing and three enthroned figures appear between the Corinthian columns with bases and capitals. An archbishop with a pallium is shown on the left; in the middle, a figure dressed in ahistorical attire gives his blessing with a book; to the right is a king with crown, scepter and the globus. The identities of Pope Sylvester II, St. Peter, and Emperor Otto are suggested by the letters S(AN)C(TU)S carved into the ivory below the middle jeweled band, OTTO beneath the king, and the three vertical lines beneath the enthroned figure on the left. The attributes of the standing figures suggest two archbishops (pallium), two bishops (bell chasuible and staff), and one abbot.

Judging from the significance of the enthroned figure, the archbishop to the left of Emperor Otto might be his Chancellor, Willigis of Mainz, but could also be St. Benedict.

The upper edge of the vessel is formed by a tendril frieze with hunting scenes, interrupted by two male, bearded masks at the handle edges.

The representation of this unique vessel has been largely interpreted with regard to the city of Heaven: "Lift up your heads, O ye gates; and be ye lift up, ye everlasting doors; and the King of Glory shall come in" (Psalms 24:7). Through the prominent placement of the king next to St. Peter, the vessel may refer to Otto III's conception of duty known as the "servus apostolorum." The connection to Aachen is established by way of the vessel's features, whose two levels, octagonal shape, and columns in the upper level have their parallels in the Carolingian Palatine Chapel in Aachen.

The excellent state of the ivory situla's preservation, its sumptuousness, as well as the unsuitability of the material as a vessel for holy water, all suggest that it was intended for isolated use at a coronation. Before its restoration, it was located at the pulpit of Henry II as a lectern shaft.

Although no stylistically similar works have been preserved, comparisons have been made to an ivory panel with the Vision of Isaiah in London, the Crucifixion of the book cover of the Codex Aurus in Nuremberg, panels with Christ in Majesty as well as Moses and Thomas in Berlin, and an ivory panel with a depiction of Paul in Paris. GM

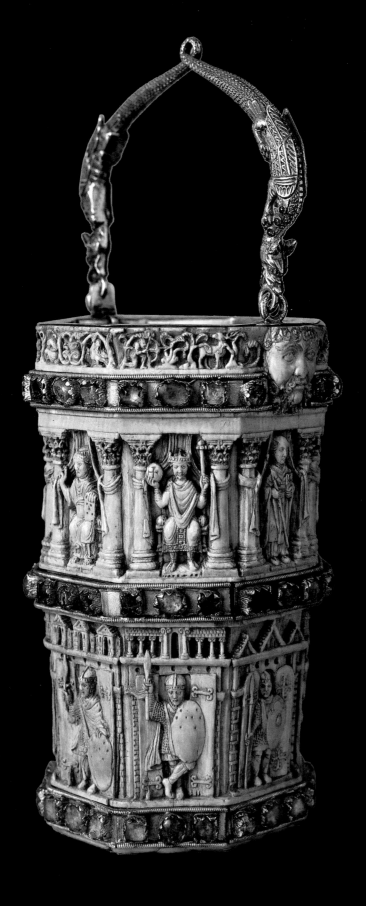

The Church of St. Mary

The Aachen Cathedral is one of the oldest churches dedicated to the Virgin Mary north of the Alps. Emperor Charlemagne dedicated it to the Mother of God and Christ the Redeemer and furnished the church with selected treasures displaying the glory and magnitude of the Mother of God. Not least of these were the precious relics of the Virgin, the garment and the belt of Mary. These had been venerated for centuries as the visible proof of the Virgin's life on earth and justified the great devotion to the Virgin Mary.

The artists, the goldsmiths, sculptors, and painters took into account this cult of the Virgin. Every entrance leading to the Palatine Chapel is adorned with representations of St. Mary, which remind the faithful of her patronage as they set foot into the Cathedral.

The Cathedral Treasury with its numerous representations of the Virgin Mary also reflects the cult of worship which surrounded her: as the Queen of Heaven, as the bearer of God incarnate, as icon, and as the central figure upon altarpieces, surrounded by patrons, saints, and donors.

HL

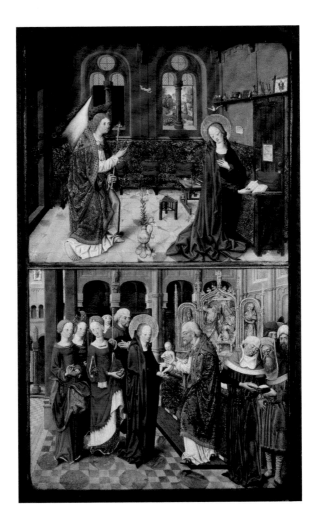

Madonna With Donor

- Lower Rhine or Aachen (?), around 1350/60
- Hammered silver, partially gilt
- H. 62 cm

The Virgin Mary assumes a lightly bent, relaxed posture, while the infant held in her left arm points to the kneeling, armor-clad donor at the statue's base. A large aquamarine (as a brooch) serves as a compartment to store relics. Beneath the infant Jesus, the Virgin's robe falls in loose folds around her body that create a cascading pile of folds. The gaze of the Virgin Mary is directed towards the distance. The oval form of her face, her expression, as well as the curls which fall to her shoulders, are reminiscent not only of French and Lower Rhine-Cologne examples; it appears as though the goldsmith also turned to an example from a century earlier, the figure of St. Mary from the Shrine of the Virgin Mary in Aachen. HL

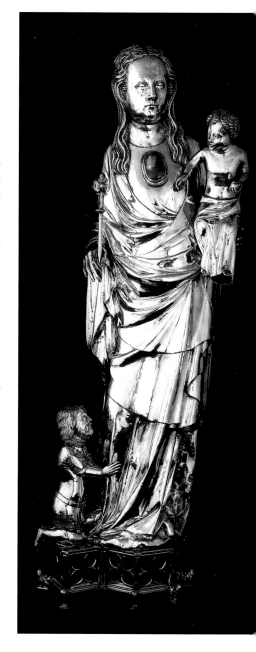

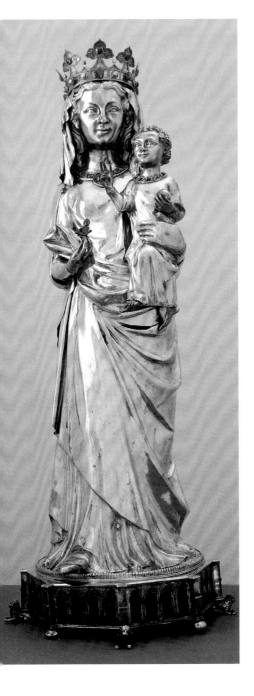

The Virgin Mary and Child

- Aachen, about 1280
- Hammered and partially gilt silver; precious gems
- H. 80 cm

St. Mary stands upon an architecturally constructed base, which probably came from a different context and was intended for the storage of relics. The statue of the crowned Virgin appears monumental. She stands upright, her robe falling in deep, rounded folds about her. The wide, flat face with its almond-shaped eyes and smiling mouth is framed by a head of full, loose hair. The fleur-de-lis crown is adorned with precious stones. Like a scepter in her right hand, Mary holds a flower made of amethyst stones. The infant Christ, who also sits upright on her left arm, accentuates the sculpture's monumentality. The small door affixed to the back of the Virgin Mary indicates that the statue once held relics. This manner of relic storage was abundant among wooden sculptures of the Middle Ages. The goldsmith may have been influenced by French cathedral sculpture, particularly from Amiens and Reims. HL

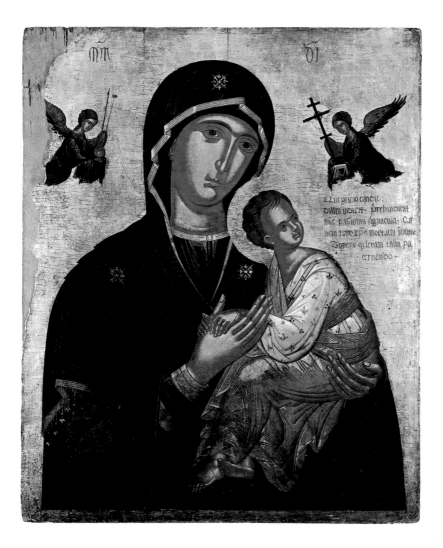

Icon of the Virgin Mary

- Chania, Crete, second half of the 15th century
- Andreas Ritzos (Andrea Rico)
- Tempera on wood
- H. 101; W. 83
- Privately donated in 1997

The icon of the Mother of God with Child and Angels is one of only fourteen preserved icons by the painter from Creta, Andreas Ritzos. It was made for a church in Italy. As a result, the inscription of the icon is also written in Latin. Over centuries, Italian Christianity was influenced by Byzantine forms of piety, so that even during the Renaissance, many Christian communities, particularly rural ones, held on to the old forms of representation.

Today, this icon in the Aachen Cathedral Treasury is a symbol of Eastern and Western forms of piety which were already united 1200 years ago within Charlemagne's Church of St. Mary. GM

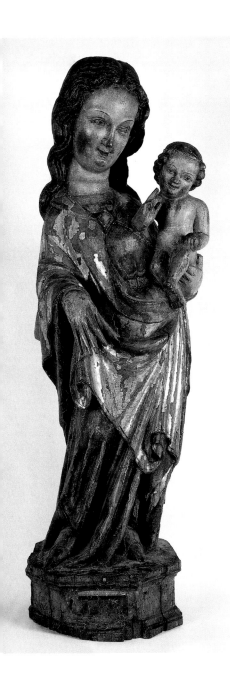

Standing Madonna

- Mainz or Cologne, about 1320
- Wood with a portion of the original form
- H. 93 cm
- Private donation 1994

The standing Mother of God carries the infant Christ in her left arm. As the judge of the earth, or *Weltenrichter*, Christ crosses his legs in the manner of a medieval judge. His left holds the globus, His right is raised in blessing as he gazes at the viewer. Over a golden-belted green tunic, the Madonna wears a red-lined cloak which is fastened by a brooch. Her long, wavy hair falls freely to her shoulders in an indication of her virginity. At one time, her right hand held the scepter of the Queen of Heaven. The open, broad-planed countenance of the Madonna, with its high forehead, narrow brow, almond-shaped eyes, dimpled cheeks, and small mouth corresponds to the contemporary standard of beauty of its origin (probably Cologne). The apprehensive gaze of the Madonna, aware of her Son's fate since the words of the ancient prophet Simeon, is directed towards the distance.

The Madonna stands in what is referred to as contrapposto, namely, with her weight resting upon one leg. This leads to a slight S-curved posture throughout the entire figure, in which the sculptural forms interplay with vertical elements. The statue's physicality is emphasized by the garment, which aside from one single rounded fold, falls in smoothly ridged, accumulated tubular folds to the base. The cloak, which is gathered over the right hand and beneath the left arm, gives rise to beautiful, cascading folds that surround the statue along both sides with various degrees of emphasis.

GM

Life of the Virgin Mary

- Cologne, about 1485
- Attributed to the artist known as the Master of the Life of the Virgin Mary, or the so-called Master of John
- Oil on oak
- H. 105 cm, W. each wing 62.5 cm

Beneath a vaulted hall of columns and in front of sumptuous brocade curtains at its center, the outer altarpiece wings display the Virgin Mary and Christ in a standing position. An image of the kneeling Charlemagne, depicted as an old man, presents the infant Christ with a model of the Aachen Cathedral. To the left and right stand St. Leopardus with the sword and martyr's palm and St. Blasius with the bishop's staff and wax candle. It is thought that their bones were found together with those of Charlemagne in his shrine.

Eight scenes from the life of the Virgin Mary are displayed in pairs one above the other. From the top left are: The Birth of Mary, Visitation, Annunciation, and the Meeting of Anna and Joachim at the Golden Gate. Below are: The Man of Sorrows Encounters His Mother, the Entombment and the Assumption of the Virgin Mary, the Presentation of Jesus at the Temple and Visit of Mary to the Temple. The scenes are not presented in chronological order, but are instead determined by the eight particularly celebrated Marian feasts of the former Collegiate Church.

Within radiant colorful scenes, often using what is referred to as pressed brocade, the artist's figures, with their stalwart, rough faces, are rendered as his contemporaries. Each scene is embellished with diverse, lovingly delineated, narrative details.

The landscape, as well as the architecture, seems regional in nature. Nevertheless, Oriental features such as the Turkish half-moon resting upon the domed building and the representation of an elephant indicate the painter's attempt to represent Palestine, the actual location of the events shown.

The altarpiece belongs to the large apsis altar of the Gothic choir. There, they provided the doors in front of the Ottonian Pala d'Oro which formerly constituted the center of an altarpiece.

The unknown painter originated from the circle of the Cologne Master of the Life of the Virgin, whose Life of the Virgin Mary altarpiece (Munich) he adapted as the standard for several panels. Additional relationships exist with the artist known as the Master of the Bonner Diptych, as well as to the painting of contemporary Brussels and the Middle Rhine. GM

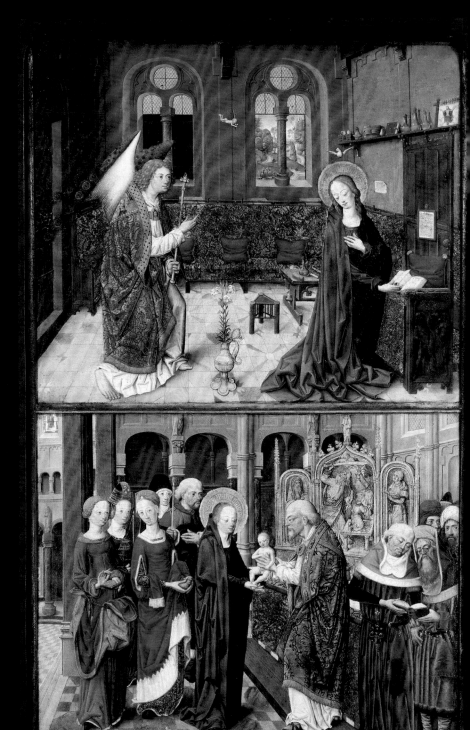

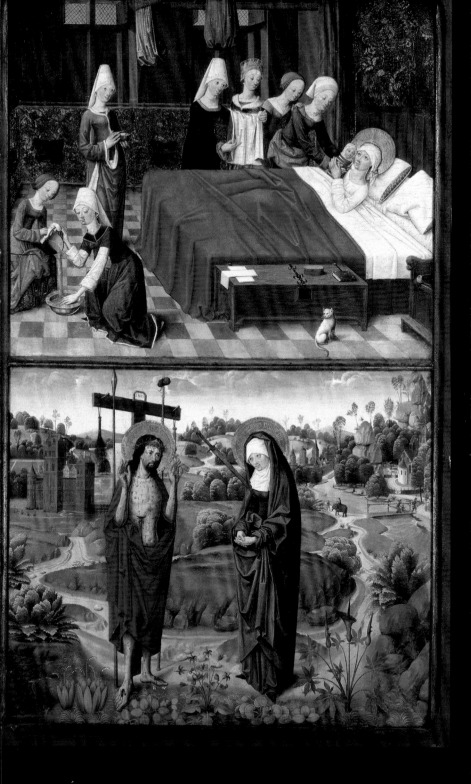

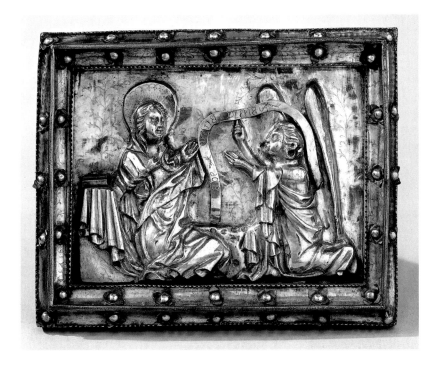

Choir Robe Brooch

- Aachen, early 15th century
- Hammered and gilt silver, pearls
- H. 13 cm, W. 16 cm

Kneeling before her prayer stool, Mary turns towards the angel who genuflects before her. He points towards the scroll, upon which the words, "ave gratia plena" are engraved. A double row of small rosettes forms the frame of the brooch. The softly-flowing, piled folds of the robe are typical of what is known as the soft style from the early 15th century.

HL

Choir Robe Brooch

- Aachen, Cologne (?), about 1340/50
- Hammered, cast, engraved, and gilt silver, pearls and enamel work
- H. 20 cm , W. 18.6 cm

A richly decorated quatrefoil surrounds the rectangular enclosure, whose roof consists of three baldachins. Within this enclosure, Mary sits upon a pearl-adorned, throne-like bench. The book she had been reading lays open upon her lap; she turns towards the angel, who approaching from the left, kneels before her holding the banner which reads, "Ave gracia plena." The large branch of lilies with pearled blossoms symbolizes her purity. The stylistic predecessors for the figures are mostly found within Cologne, perhaps among the Annunciation group of the high altar of the Cologne Cathedral (1322). Saints Christopher and Cornelius, as

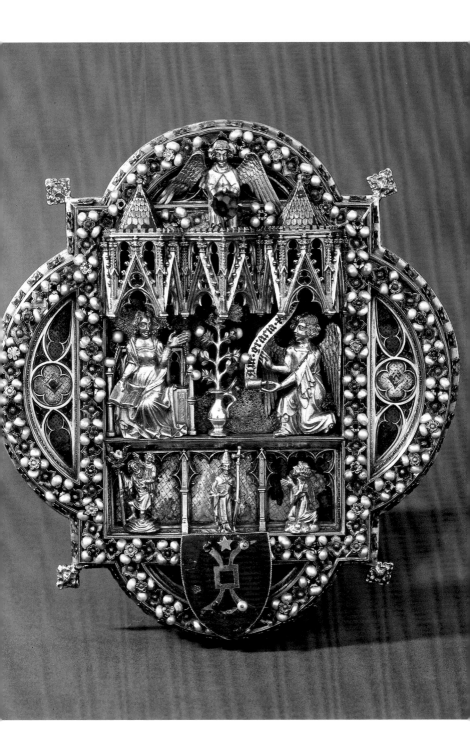

well as the kneeling donor of the robe brooch occupy the small niches within the lower zone of the enclosure. The latter is a church canon of Heimbach, whose coat of arms is located beneath the figure of Cornelius (Fritz, Goldschmiedekunst).

HL

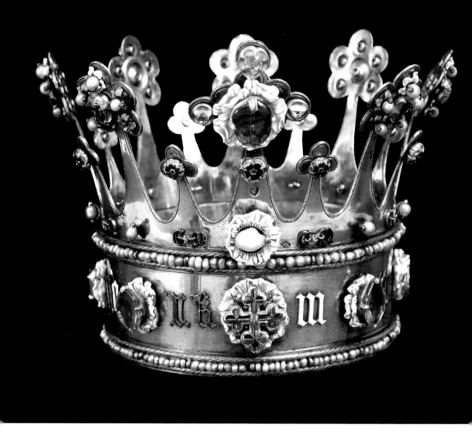

Crown of Margaret of York

- England, about 1461
- Hammered and gilt silver, pearls, ronde bosse enamel and precious stones
- H. 13.2 cm, circlet diameter 12.5 cm
- Restored by the Aachen goldsmith Vogeno in 1865 at the expense of the Crown Prince Frederick

Upon the circlet adorned with two rows of pearls, the name Margarit(a) de (Y)o(r)k is legible; at the base of the prongs, the letters C and M repeatedly appear. The white rose of York with a diamond wreath at its front corresponds to the Valois-Burgundy coat of arms on the back. It is possible that Margaret of York first wore this crown in 1461 at the coronation of her brother, Edward IV of England and then at her wedding in 1468 to Charles the Bold in Damme. The initials CM and the Burgundy coat of arms attest to this. On July 22, 1474, Margaret of York spent some time in Aachen and either on this occasion or later, donated the crown to the venerated statue of the Virgin Mary. Up until now, the crown serves as jewelery during the procession of relics. A child-sized crown was constructed for the Christ Child of the devotional statue. The leather case features the bridal couples initials, CM, the coats of arms of England and Valois-Burgundy, marking the alliance between the two houses, as well as the motto of Margaret of York: "BIEN EN AVIENIE." Late Gothic tendrils and stylized dragons are deeply embossed into the leather, covering the remaining section of the case. HL

Ornamental Necklace

- Paris or Burgundy 1st half of the 15th century
- Gilt silver, ronde bosse enamel, pearls
- Restored during the 19th century

The 38 chain links are embellished with blossoms, filigree work, gems, and pearls. The work is dominated by the blue-white enamel hue. The golden pendant, which is suspended by a delicately formed chain, is shaped like a teardrop. Its contours are formed by two thorny, pearl-adorned branches and crowned with a fleur-de-lis crown. A small cherub-like figure, holding a spoon and bowl in his hands, emerges from a blue-enameled blossom. The 16 small Burgundian clasps with secular images in the Essen Cathedral Treasury invite comparison to the drop-shaped pendant. HL

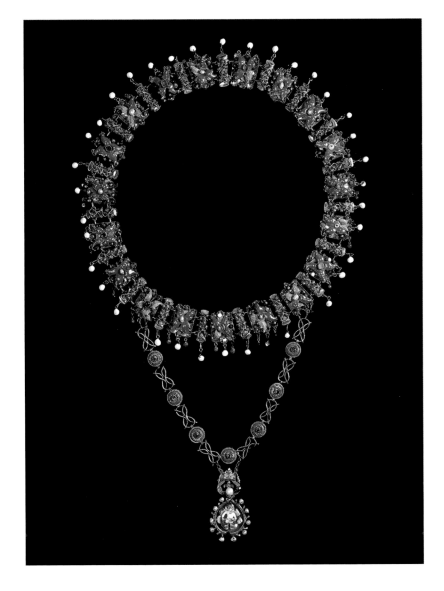

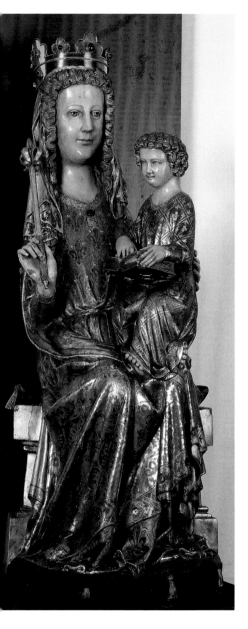

Madonna Enthroned

- Meuse-Rhenish, early 14th c.
- Oak wood with 19th-century attachment
- H. 110 cm
- Acquired from the Mutterhaus der Schwestern vom armen Kinde Jesus in Aachen in 1876, after which it was extensively restored.

The Mother of God sits facing austerely forward upon a cushion-covered, throne-like bench, with her feet resting upon a stool. The gaze of the open, broad-planed countenance of the Virgin Mary, with its almond-shaped eyes and dimpled cheeks, is directed to an unspecified point in the distance. Like a veil, her curly, shoulder-length hair frames her face.

The crown, as well as the right hand with the fleur-de-lis scepter was reconstructed in the 19th century. Upon the Virgin's lap and supported by her left hand, sits Jesus as the young King. He points to the Book of Gospels in his hands. Thus, the Mother of God is the throne of Solomon, the seat of true wisdom. Together with representations of Madonna Enthroned in a private collection in Aachen as well as in Frankfurt, this Madonna belongs to a group which is situated between the so-called Aachen Madonna in Cologne or the Madonna of the Maries and the Shrine of Remaclus, and the Cologne seated Madonnas of the 14th century. A copy of the Madonna Enthroned is located in Salzgitter. GM

Devotional Statue

- Heads and the Virgin's right hand Cologne (?), first quarter of the 14th century, acorn
- Statue Aachen 1676, limewood
- Color version of 1676
- H. 125 cm

The standing Mother of God carries the Child upon her left arm. Christ gazes at the viewer. The visage of Mary, with her high forehead, narrow brows, almond-shaped eyes, dimpled cheeks, and small mouth, corresponds to the contempo-

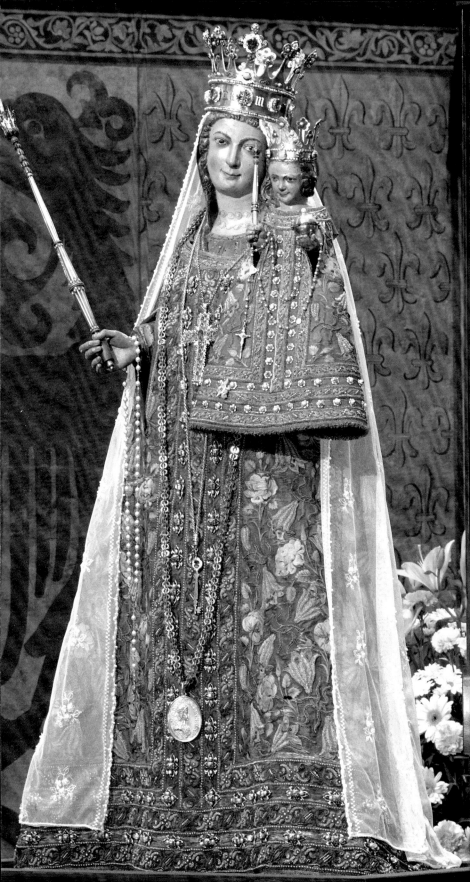

rary standard of beauty of its origin (probably Cologne). The gaze of the Virgin Mary is directed lovingly at the child, whose fate she has known since the words of the ancient prophet Simeon.

She stands in what is referred to as contrapposto, namely, with her weight resting upon one leg. This leads to a slight S-curved posture throughout the entire figure, in which the sculptural forms interplay with vertical elements.

The devotional Gothic image of Our Dear Lady of Aachen fell victim to fire in 1676. The limewood statue which was carved directly after the fire retained its Gothic appearance. It was replaced with the salvaged heads of the Mother of God and of the infant, as well as the right hand of Mary. The Gothic statue belongs to a group of sculptures which came into existence in the first quarter of the 14th century and were influenced by North French examples. To this group belongs the choir figures and the so-called Milan Madonna, both in the Cologne Cathedral. GM

Sunburst Madonna (Cathedral)

- 1524
- Jan Bieldesnider (= Jan van Steffeswert)
- Oak, newly attached in 1849
- H. of the Madonna 172 cm
- Present-day form 1685

The sunburst Madonna, which is suspended from the choir vault, consists of a dual portrait of the Virgin Mary with Child in front of a gold border of clouds and surrounding sunburst wreath. In each instance, Maria holds the seam of her garment while holding with reverently covered hands, the naked Christ in her arms.

The figure of the Virgin Mary, which faces the Palatine Chapel, represents the heavenly symbol of the Apocalyptic Woman. She is the new Eve, who stands upon the crescent moon and the conquered serpent of evil coiled around it. She extends towards the viewer the Christ child, who as the new Adam, holds an apple in His hands. Angels hover about the figure of the Queen of Heaven. They carry scepters, crowns, and three signs with the inscription, "Dilecta deo/Angelis et/Hominibus" ("Chosen by God before angels and men"). The side of the choir apsis and with it, the erstwhile choir altar, refers to the Eucharistic sacrifice. The Christ child, whose right hand is raised in blessing, holds a grape in His left hand towards the angels, who in turn reach for it as they playfully clamber up the robes of the Mother of God. The signature and master mark of the Maastricht wood carver Jan van Steffeswert and the date 1524 are on the reverse side of the two lower signs on the Chapel. Jan van Steffeswert was the only wood carver of the Meuse region who signed his works during this time and is therefore the only Netherlandish artist from the Late Middle Ages to emerge from the anonymity of the era.

The most recent restoration in 1996 revealed that the entire double portrait had been single-handedly completed by one artist and enabled its reconstruction of its original appearance as a rosary Madonna. After the image was damaged in 1656 from a town fire, it was installed as a sunburst Madonna in 1685. A white-gold setting was mounted in 1782, followed by a new setting in 1849 which was consistent with the surviving elements of the medieval one. GM

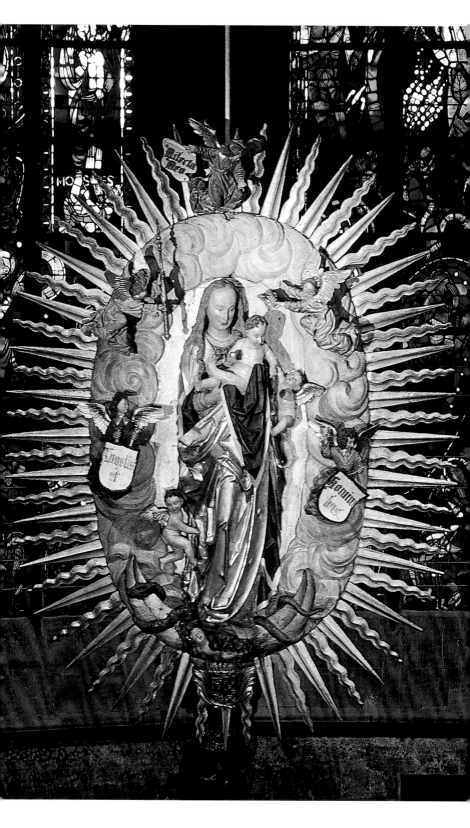

91

Altar of the Holy Virgin Mary, so-called Falkenstein Altar

- Aachen (?), early 15th century
- Tempera on canvas
- H. 140 cm, middle panel 84 cm, wings W. 37 cm

Following the Italian example of the Sacra Conversazione, or holy conversation, several apostles surround the step-like throne in which the Mother of God tenderly cradles her child. Beneath the open curtains upon an ornamental tile floor, appear from left to right: Apostle Matthew with the axe and book, Saint Erasmus wearing the bishop's garments, Saint Mary of Egypt in a hairshirt, Saint Benedict with the habit, crozier, and the open book showing the Rule of his Order. Atop a gold background which was possibly restored in 1833, two angels hold the crown of the Queen of Heaven

over the head of the Virgin. Beneath stone-like painted baldachins, the Apostles Peter and Paul endorse the kneeling donors of the winged altar. Based upon the visible coats of arms, they are likely the Archbishop Cuno († 1388) of Trier and Werner († 1418) of Falkenstein.

The outer wings of the altarpiece shows a grass surface in front of a red, rosette-embellished background. Except for feast days, this was the only visible section of the altarpiece. Shown here are Saint John the Baptist with the Lamb of God on the sealed book, as well as Emperor Charlemagne with a tall arched crown, globus cruciger, and robe adorned with griffin motifs. With the left hand, Charlemagne points to an imaginative model of the Aachen Cathedral at his feet.

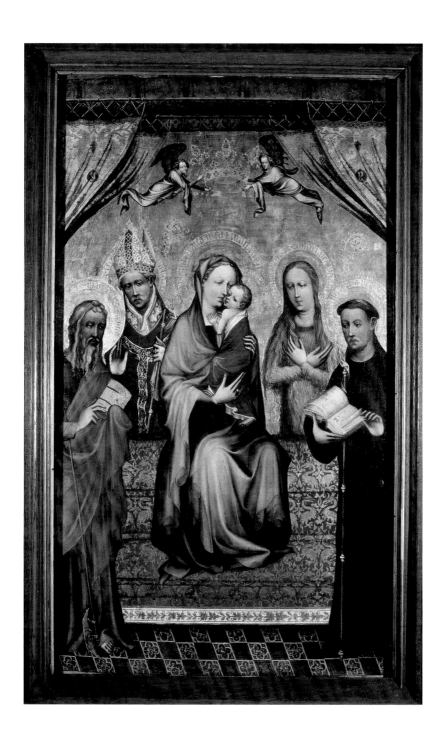

The winged altar was located behind the throne of the Nicasius altar until 1878 and at the north choir altar until 1932. From then on, it was situated at the altar of the Michael Chapel. Because a baptismal font was located behind the throne, the representations of Charlemagne (throne) and John the Baptist (baptismal font) on the outer wing probably refer to the placement of the altar's display. GM

The Pilgrimage Church and its Reliquary Treasure

Since the era of Charlemagne, the Aachen Cathedral has held a large reliquary treasure.

Relics are mortal remains of saints or artifacts associated with saints which then became objects of veneration. They are kept within luxurious containers and shrines. During the Middle Ages, a church's prosperity was considered primarily with regard to its possession of relics and sanctuaries, which were the destination of pilgrims.

Rome, Jerusalem, Santiago de Compostela, and Aachen were the most important destinations for the faithful who made their way across Europe towards the healing powers of the relics. The Aachen Cathedral enjoyed a particular appeal as the burial church of Charlemagne and the coronation church of the German kings. Since 1349, the Aachen relics have been put on display. From the Shrine of the Virgin, the four major relics, namely, the textile relics which recall the earthly lives of the Virgin Mary, Christ, and John the Baptist, are taken and placed for veneration in the Cathedral. In earlier times, they were also displayed from the tower galleries of the Aachen Cathedral. Some of the sumptuous reliquary containers, altars, and altar furnishings can be traced to royal donations and endowments.

HL

Saint Peter

- Aachen, about 1510
- Marked with the master's mark of the Aachen goldsmith Hans von Reutlingen and the Aachen city inspector
- Hammered and partially gilt silver
- H. 72.5 cm

In his right hand, the statue of Saint Peter holds a chain link with which he was shackled in the dungeons in Rome; in his left hand are the keys to Heaven with the cross. A halo with pierced arabesques surrounds the head of the saint. The small patch of hair above the forehead, the bare scalp, as well as the thick, wavy hair which grows over the ears, match the hairstyle associated with early representations of the saint. The base, a six-sided box with small columns and adorned with tracery windows, serves as a relic container for the skull relics of an unknown saint. HL

The Donation of King Louis I the Great of Hungary and Poland

In 1367, Louis I the Great from the House of Anjou, King of Hungary and Poland, endowed the Hungarian Chapel to the Aachen Cathedral. This was accompanied by a donation. Henry, Abbot of Pillis, had supervised the construction of the chapel and on October 27, 1367, gave an account of the royal gifts of liturgical instruments for the chapel.

Aside from liturgical vestments, the following items that have been kept in the Aachen Cathedral Treasury until now, comprise a part of the donation: two silver-covered panels, silver candelabra, and monstrances with relics of the holy Hungarian kings Stephen, Ladislaus, and Emerich.

In 1381, Abbot Ulrich was sent from Pilis to Aachen in order to take inventory. He compiled a new list and in addition, noted "duae cappae choralis cum decenti decoratu" ("two choir robes with attractive adornment"). These were undoubtedly two choir brooches. The panels and choir brooches bear the Polish as well as Hungarian coat of arms, and for this reason, a date after 1371 (which was the year of Louis' coronation as King of Poland) has often been suggested. However, their date of origin must have been earlier than 1371, since the panels had already appeared in the first inventory of 1367. In 1340, Louis I was the first Polish crown prince and was allowed to use the Polish coat of arms. The coat of arms consists of two shields. The Polish coat of arms displays the double cross and the eagle. The Hungarian coat of arms bears the bustard, which holds a horseshoe in its beak, as well as the divided coat of arms with the silver-red bars and the fleur-de-lis of the Anjou.

HL

Madonna and Child

- Hungary, before 1367
- Tempera on wood (overpainted)
- Silver plate, hammered, embossed, gilt, enamel and precious stones
- H. 58 cm, W. 50 cm

The painting is framed by metal work in the manner of a Byzantine icon. The outer frame consists of hammered panels with ornamental foliage, and the Polish and Hungarian coats of arms. The Madonna, seen in half-length, supports the Christ Child, who turns towards her. His right hand is lifted in blessing; the left hand rests upon the open book. The cloak of the Madonna repeats the fleur-de-lis decorative motif seen in the background. The halos of the Madonna and Christ are embellished with precious stones. HL

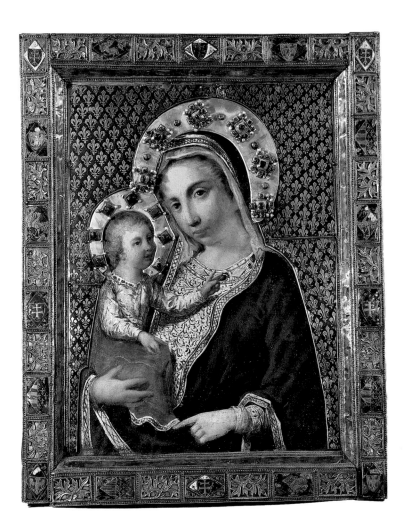

Madonna and Child

- Hungary, before 1367
- Tempera on wood
- Silver plate, hammered, embossed, gilt; enamel and precious stones.
- H. 52.5 cm, W. 42 cm
- Extensively restored in the 19th century

The frame of the panel displays the Hungarian and Polish coats of arms alternating with hammered arabesque plates. A blue enamel base with golden fleur-de-lis serves as the background and is cut around the half-figure representation of the Madonna and Child. The Madonna wears a dark blue cloak over a gold garment and points towards the Christ Child with her left hand. With the right hand, she holds the infant Jesus, who wears a gold-red robe and points to His mother with His left hand. The halos are made of gilt silver plate trimmed with precious stones.　　　　　　　HL

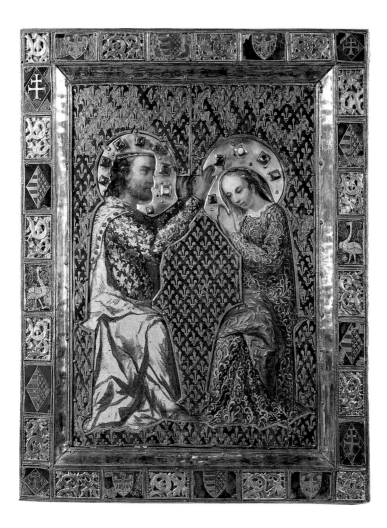

The Coronation of the Virgin Mary

- Hungary, before 1367
- Tempera on wood
- Silver plate, hammered, embossed, gilt, enamel, precious stones
- H. 52 cm, W. 42 cm

The painting is framed by metalwork in the manner of a Byzantine icon. The coats of arms which appear on the frame point to Hungary and Poland, while the fleur-de-lis background refers to the Anjou line. The painting displays the enthroned Christ, who turns towards His mother in blessing. It is possible that his hands once held a crown to coronate the Virgin, but this can no longer be confirmed.

In the two inventory lists of 1367 and 1381, only two panel paintings were mentioned, thus making it impossible to determine which of the three panels was added. Because the panels of the Coronation of the Virgin Mary and the Madonna and Child panel piece show consistencies in terms of the sequence and shape of the coats of arms, it can be assumed that they belong together.

HL

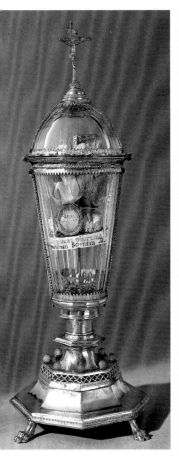
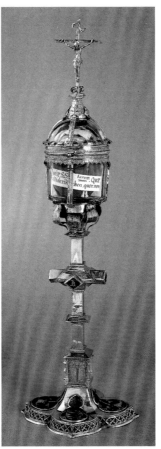
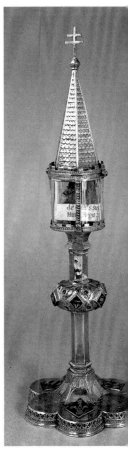

Reliquary

- Vienna (?), early 15th century (?)
- Cut rock crystal with cover; base, stem, and setting hammered, cast, gilt silver; coral pearls
- H. 34.5 cm; diameter of base 13 cm
- The inspection mark at the base displays a coat of arms with two crossed keys on the upper right and three beams on the upper left; beneath them is a figure.

The form of the reliquary is the most clear and elegant of the three reliquaries containing the relics of Hungarian saints. It contains the relics of Saint Stephen, King of Hungary and his son Saint Emericus, as well as relics from Saint Ursula and her companions. The container is inserted into the gold work and crowned by a cross.

The relics of Stephen and Emericus were part of the royal gift from 1367; three reliquary monstrances for these and other relics are also mentioned. The reliquary displayed here bears no coat of arms. Based on stylistic findings, it did not come from the period of Louis the Great's donation and was used only later to contain relics.

HL

Reliquary

- Hungary, before 1367
- Cut rock crystal vessel with cover; hammered, cast, engraved, and gilt silver; enamel
- H. 42 cm, Diameter 13 cm

The wide, Late Gothic base features the coat of arms of the Hungarian Anjou lineage and the bustard. The relic holder consists of a small cut rock crystal receptacle with lid, which was inserted into the gold work and crowned by a cross. The node of the multifaceted shaft displays the cross inscription INRI.

According to the inscription surrounding the reliquary, it contains relics of saints that were found beneath the altar in Diederskirchen, as well as relics from Saint Catherine and Saint Agnes.

HL

Reliquary

- Prague (?), before 1367
- Cut rock crystal vessel; hammered, cast, gilt silver; enamel
- H. 32.5 cm, diameter of base 10.7 cm

The reliquary container consists of a polished cut rock crystal vessel upon a high shaft. Its enclosure is capped with a cover resembling a shingled roof. The Hungarian Anjou lineage and bustard appear at its base. The reliquary contains the relics of Saint Stephen I (King of Hungary) and other saints.

Comparable reliquaries are located in the St. Vitus Cathedral in Prague, in the Secular Treasury in Vienna, and in the parish church Herrieden/Ansbach. According to its inscription and coat of arms, the latter is a donation from Emperor Charles IV.

HL

Two Acolyte Candlesticks

- Hungary, before 1367
- Hammered and partially gilt silver, enamel
- H. 22.8 cm
- The candle bases are collapsible

Both candlesticks bear the coat of arms of the Hungarian Anjou lineage: the eight silver and red enamel beams from Hungary, the gold fleur-de-lis upon a blue background, and the crest of the Hungarian kings with the bustard with a horseshoe in its beak. The word acolyte refers to "companion." In the Catholic Church, an acolyte is a fourth-level cleric of the minor Orders, who has no actual authority.

HL

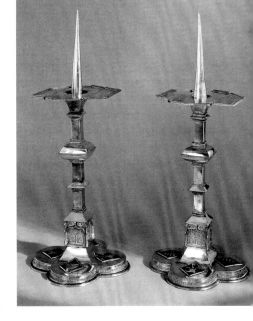

Two Choir Robe Brooches, Each With Two Shields

- Hungary, before 1367 (?)
- Hammered, cast, and partially gilt silver, silver enamel
- H. 22 cm, W. 16 cm

Both brooches were probably accompanied by two shields and adorned the cloth closures and openings of choir robes. The two bearded male heads with crowns which appear on both brooches refer to the Polish duchy of Dobrzin and with it, to Elisabeth, the mother of King Ludwig I, who made a pilgrimage to Aachen in 1357. The shield of the Hungarian Anjou line, surrounded by diminutive steepled architecture and an arched banner, is held on either side by two griffins. The ban-

ner bears the inscription: "Gottes lere wold ich mere/ich beger Maria lere." The coats of arms are crowned by large architectural cityscapes. Beneath the canopies are displayed the Hungarian protective saints of Stephen, Ladislaus, and Emericus. Relics from these three patron saints were donated to the Hungary Chapel in 1367.

As in the large choir robe brooches, two of the shields display the coat of arms of the Anjou line and as a helmet embellishment, the bustard with horseshoe in its mouth. The other two display the coats of arms of the Polish empire and the eagle, the Polish heraldic animal, as decoration.

HL

Chalice

- Hungary, early 16th century
- Silver, partially engraved, hammered, gilt, filigree work, enamel
- H. 18 cm

Filigree-worked tendrils with grapes and rosettes decorate the blue- and green-enameled surface of the chalice. The flat, wide node is embellished with enameled pearls and rosettes. In terms of its proportions and technical execution, the chalice is closely related to a second chalice, probably also from Hungary, of the Aachen Cathedral Treasury.

Nothing is known of origins of the chalices. They might have originated from a donation which was made to commemorate a pilgrimage to Aachen. It has been surmised that the donor was the sister of Charles V, Maria of Hungary (1505-1558), who had an "undeniable" fondness for Aachen (Jülich, Die ungarischen Kelche).

HL

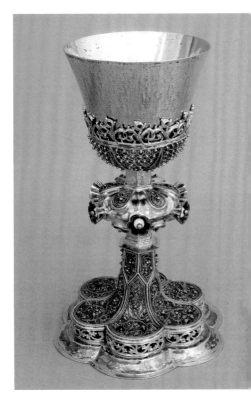

Chalice

- Hungary, early 16th century
- Silver, partially engraved, wrought, gilt: filigree work, enamel, corals
- Restored in 1861 according to an inscription at the base.
- H. 22.8 cm

The six sides of the chalice base and shaft, as well as the cup basket are embellished with rich filigree decoration, through which the enamel shimmers. Upon the node, coral pearls have been fitted between the engraved surfaces.

HL

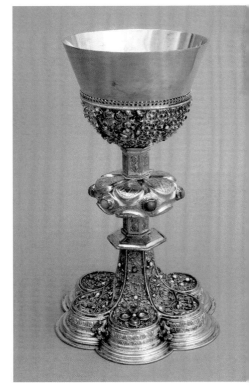

Shrine of the Virgin Mary (Cathedral)

- Aachen, 1220 to 1239
- Oak core; hammered and gilt silver; stamped silver, engraved beams, opaque silver enamel, filigree work with stone trimming, antique and medieval stone fragments
- L. 184 cm, W. 54 cm, H. 95 cm,
- The shrine was stabilized and conserved from 1989 to 2000 in the goldsmith's workshop of the Aachen Cathedral Treasury. The tree which was used to make the shrine's case was felled in 1210 A.D. After conservational measures were completed, the shrine was placed in the Cathedral at the location it had occupied from 1239 to 1786. See also the wall painting (late 17th century) at the south wall of the Cathedral choir polygon (Karlsverein-Dombauverein, Vol. 4, 2001).

The shrine assumes the form of a single-nave church with transept. The Virgin and Christ, both crowned, sit enthroned in the center of the front side. On the opposite side is Charlemagne; on the left face is Christ, and on the right face is Pope Leo III. Beneath pointed arcades along the nave sit the twelve apostles. Their names appear above them in enameled writing. The roof surfaces display scenes from the Life of Christ, beginning with the Annunciation of the Angel to the Virgin and concluding with the Entombment. Enamel and filigree work, gilt stamped silver, as well as over a thousand precious stones, including medieval gems and cameos, comprise the shrine's ornamental decoration. The roof surfaces are restricted by cast ridges, upon which seven large knobs have been attached. The Shrine of the Virgin Mary is the first of its kind from the Meuse-Rhenish region, in which the precious metal, gilt silver was exclusively used. It follows that the technique of opaque (not clear) enamel upon silver plate was applied here for the first time. The architecture of the shrine does not emulate large-scale architecture; rather, it is much more an expression of the vision of the golden enclosure as an image of Heaven, the place of God. In the same way that a church building provides a large-scale illustration of Heaven, the shrine achieves the same on a small scale. Since 1239, the shrine has contained the four major relics of the Aachen Cathedral Treasury. According to tradition, they consist of the dress of the Mother of God, the swaddling clothes of Jesus, the decapitation cloth of Saint John the Baptist, and the loincloth which Jesus wore on the cross. These ancient textiles have been venerated for centuries as the visible, tangible signs of the earthly lives of the Virgin Mary, Christ, and Saint John. It is likely that they have been part of the Cathedral Treasury since the era of Charlemagne. In terms of style, the Shrine of the Virgin Mary remains consistent with the tradition of the Meuse-Rhenish shrines. However, it already displays the conflict with the beginning of the Gothic Period. The shrine was first mentioned in 1220 and was apparently already being built at this time. In all likelihood, at least two goldsmiths worked on this shrine. It is assumed that shortly before the completion of the Shrine of Charlemagne (1215), an older goldsmith began work on the Shrine of the Virgin Mary and continued working in the style of the Charlemagne shrine, while a younger goldsmith, open to new ideas, created sculptural, dynamic, "Gothic" figures. The influence upon the workshop of the Shrine of Remaclus in Stavelot (of 1240) is demonstrated through numerous ornamental and figural details.

Since 1349, the shrine has been opened every seven years and the relics have been removed for exhibition from the tower galleries of the Cathedral. This custom, known as the "Heiltumsweisung" prevailed until the close of the 20th century. The pilgrimage continues to take place every seven years; however, the relics are no longer displayed and venerated from the tower galleries of the Cathedral, but from within and in procession outside the Cathedral. Pilgrims make their way from all parts of Europe in order to venerate the Aachen relics in the seventh month (July) of the seventh year for two periods of seven days (Wynands, Der Aachener Marienschrein). HL

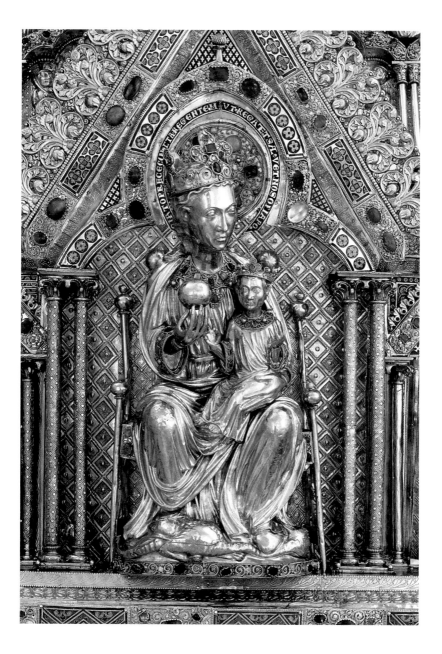

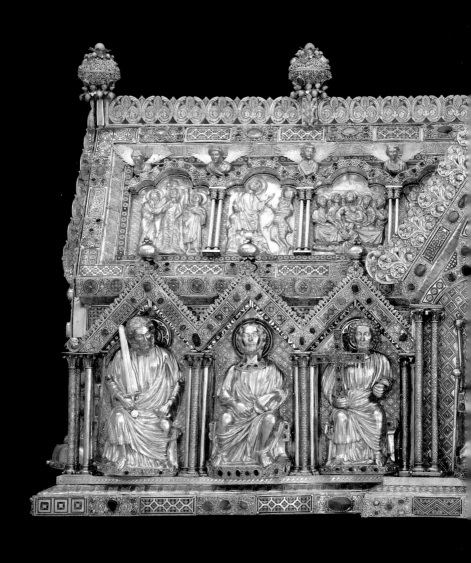

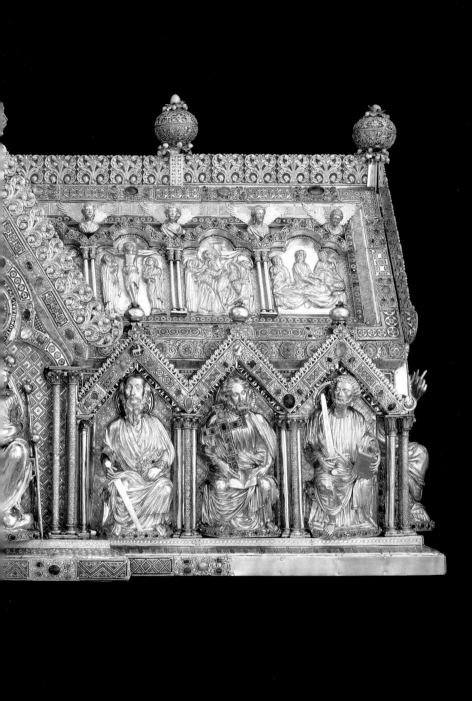

Locks of the Shrine of the Virgin

For over six hundred years, the Shrine of the Virgin Mary is opened every seven years to mark the pilgrimage. The figure of the Virgin Mary is removed, the door which becomes visible behind it is locked with a padlock and sealed with lead for the preliminary pilgrimage. The keys are divided and each distributed to the Cathedral and to the city council as the two institutions to guard the relics. The so-called co-custodial right of the city has been asserted since 1424.

Since the beginning of the 20th century, artistically rendered padlocks have been made for the Shrine of the Virgin Mary, which not only reflect the goldsmiths'

imagination and artistry, but also enable one to experience the spirit of the age and the historical context of their creation. Particularly impressive are the simple locks which were manufactured during the dire circumstances of the war and post-war periods. In 1945, a "small" pilgrimage of relics took place apart from the seven-year rhythm, after the Cathedral Treasury had been returned post-surrender, from its wartime storage location to Aachen. The simple padlock used to secure the Shrine of the Virgin was adorned with a five German mark coin that had been donated by a Cathedral canon. HL

Heraldic Chest of Richard of Cornwall

- Limoges, circa 1258
- Leather and wooden chest with red glaze, as well as 40 copper-gilt medallions with enamel and metal fittings
- H. 38.5 cm, W. 79 cm, D. 40 cm

During the pilgrimage which takes place every seven years, the Shrine of the Virgin Mary is open for display in the Cathedral. At night, the four major relics are kept locked in this chest. Up until the 19th century, the relics were placed within the heraldic chest in one of the two tower chapels in order to safeguard them.

Together with decorated metal fittings, forty gold medallions embellish the chest. 17 of these medallions display hunting and dueling scenes, as well as falcon hunts and animal representations, while the other 23 medallions display four different coats of arms. They have been identified as those of Guy VI, Viscount of Limoges († 1263), Duke Henry III of Brabant († 1261), Archambaud IX of Bourbon († 1262), and the Dukes of Burgundy. The first three are the family coats of arms belonging to the children (by marriage) of Duke Hugo IV of Burgundy. The most recent date of marriage is the summer of 1258, when Hugo's daughter Marguerite wed Guy VI of Limoges, which was her second marriage. In November of the same year, her father Hugo married for the second time. His wife was Beatrice, the sister of the King of Navarra and Count of Champagne. This coat of arms does not appear on the chest, thus the chest was probably completed between the marriage of Marguerite (summer 1258) and that of her father Hugo (November 1258). Comparable works are found in the chests of the Namur Cathedral, the so-called Chest of St. Louis in the Treasury of the Church of Our Lady in Tongeren, one in the Victoria and Albert Museum in London (the so-called Valence-Cassette) and another chest in the Abbot Treasury of Conques. According to tradition, the heraldic chest is connected to Richard of Cornwall, who was crowned king in 1257 in Aachen and in 1262, donated the chest to the Aachen Coronation Church. See also the Scepter of Richard of Cornwall. HL

Shrine of Saint Speus

- South Italy, 11ᵗʰ century (?)
- Wooden chest with nailed bone plates and copper-gilt corner hooks and hinges; silver-gilt metal bands Aachen, around 1165/70
- H. 34 cm, W. 51 cm, D. 32.2 cm

With regard to its form, the rectangular wooden shrine somewhat resembles a chest altar. The surfaces of the base and cover are adorned with silver-gilt stamped metal. An inscription in Roman majuscule is engraved in copper along the short ends of the shrine: IN ISTA CAPSA CONTINENTVR RELIQVIE ET OSSA SANCTI SPEI / EPISCOPI ET CONFESSORIS CV(M) CETERIS ALIIS RELIQVIIS. Its translation reads: "In this shrine are the relics and bones of the holy Bishop and confessor Speus, with other additional relics." According to H. Giersiepen, the narrow letters indicate that the inscription came from the Southern Italian-Sicilian region. The silver-gilt ornamental stamped metal originated from the sty-

listic context of the Barbarossa chandelier in the Aachen Cathedral and imply that the workshop of the Barbarossa Chandelier obtained these decorative elements in approximately 1160/70. The boned plates are attached to the wooden core with numerous ivory nails. Traces of red pigment suggest that the shrine was originally painted. The lancet-shaped metal fittings can be compared to those of the ivory Sicilian reliquary boxes in St. Andreas in Cologne. According to the Aachen church records, the reliquary shrine of Saint Speus was traditionally used at that time to carry his relics during celebratory processions throughout the city.

The shrine holds 57 relics (Kessel, Geschichtliche Mitteilungen). The text of one of the confirmations is identical to that of the epitaph of Saint Speus in Spoleto and had to have been written with knowledge of this inscription, that is to say, directly in Spoleto. A fragment of the epitaph is preserved in the Museo Nazionale in Spoleto, with another in the Roman church Sant'Eufemia in Spoleto. The tomb of the saint is located in the SS. Apostoli church in Spoleto.

The relics have probably been in Aachen since the Carolingian era. In 779, it was reported in the Royal Frankish Annals that: "At that time, King Charles traveled through Neustria and arrived at the Compiègne estate, and as he made his way back towards Austria, Duke Hildebrand of Spoleto arrived with countless gifts for the magnificent King at the Verzenay estate." The valuable Speus reliquary was most likely among the numerous gifts which the Frankish Hildebrand gave to Charlemagne. They were verified in the 11ᵗʰ century in Aachen by Lambert of Hersfeld, when King Henry IV "Aquasgrani profectus sanctum Speum confessorem (…) ac-

cepit atque in Hartesburg transtulit." Giersiepen writes, "Possibly only some of the relics were handed over, for in 1076 an altar was dedicated in the Church of St. Mary, in which the relics of St. Speus, among others, were interred." (Giersiepen, Die Inschriften des Aachener Doms). HL

Shrine of St. Felix

- Italian (?), 11th century
- Wooden case with silver plate, basse-taille and cloisonné enamel
- Engraved inscription from the 16th century
- H. 23 cm, W. 50 cm, D. 22.5 cm

Four delicate small columns, crowned by bud-shaped knobs, support the reliquary case. The walls of the case are adorned with hammered arabesques and leaf work. The seemingly empty circles and half-circles, restricted by narrow rims, may have been filled with cloisonné work and pearls as shown upon the lid. The lid frame is composed of 26 cloisonné discs with arabesque and animal motifs, which probably came from another context. In the middle of the lid, four fields embellished with arabesques form a cross. Five precious gems between them complete the image of the jeweled cross, which acts to take the place of a dedicated altar stone.

An inscription added in the 16th century on the front of the shrine indicates that the relics of the holy Bishop Felix and other martyrs were stored in this shrine. The form and size of the reliquary bears parallels to the Portable Altar of Saint Andrew by the Egbert workshop in Trier (977-993), as indicated by affinities between the enamel work of the lid, cloisonné and basse-taille enamel work of the Shrine of St. Felix to that of the Trier workshop.

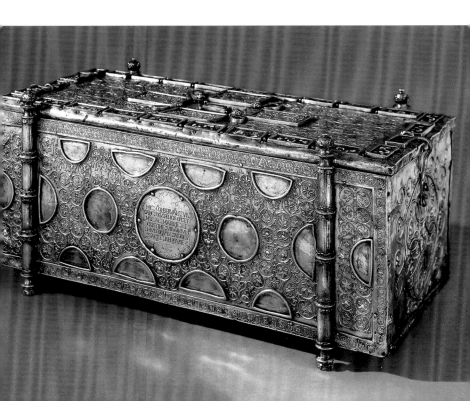

With regard to the relics, it is likely that they come from Saint Felix of Cimitile/Nola († 260). A clue to the possible provenance of the relic can be provided by the box-like marble altar that was built in around 500 over the grave of Saint Felix in Cimitile/Nola, Italy. It is supported by four slender corner pillars capped by two slim pine cones (Lehmann, Überle-gungen zur Bestattung im spätantiken Kirchenbau). It appears that the Shrine of Felix was built with an awareness of this marble altar. It repeats precisely the altar supported by four columns, as if the creation of the small shrine intended to commemorate the original grave and the first location of the relics.

HL

Reliquary of Anastasius

- Antioch, late 10th or early 11th century
- Hammered silver, partially gilt, niello inlay
- H. 39 cm, W. 19 cm, D. 20 cm

The reliquary is shaped like a cubical, domed Greek church with three winged doors adorned with crosses and an apse. The apse has three window openings. The apsis roof, the doorframes, and the creased dome are embellished with ornamental arabesques using niello techniques. The drum of the dome has seven open and seven closed arcades and is crowned by a cross-capped node. The smooth wall surfaces of the three winged doors bear Greek inscriptions. Their translation into English reads: "Glorious things are spoken of thee, O city of God." Psalms 87 (86):3. "Arise, O Lord, into thy rest; thou, and the ark of my strength." Psalms 132 (131):8. "For the Lord hath chosen Zion; he hath desired it for his habitation." Psalms 132 (131):13. The inscription which surrounds the apsis refers to the donor. The English translation reads: Lord, help your servant Eustathios, proconsul, patrician, leader of the army of Antioch and Lycandus, your servant."

The donor, Eustathios Maleinos, came from an aristocratic family and was a commander in Antioch in the months following the Byzantine takeover of the city in 969. The excerpts from the Psalms and cubic form indicate the heavenly city of Zion after the Apocalypse.

Evidently, the box was a type of ciborium to store the Eucharistic bread. The inscription does not contradict this, as it speaks of the city of God, the ark of his observance, and the Lord's dwelling. The allusion to God's symbolic presence is clear. This explains a definitive resemblance to representations of saints' graves (with three window openings) from the High Middle Ages. Incense holders formed as small churches allow for comparison, such as in the Bruciaprofumi of the Saint Mark Treasury in Venice, as well as church-formed processional lamps indicating Zion.

Whether the instrument was in existence in Aachen before 1204 and came to the Aachen Cathedral Treasury via Empress Theophanu († 991) is not clear. It is more likely that it had been located in Antioch up until the Crusades and with the crusaders, came to the West only in the late 12th or 13th century. The reliquary unites Byzantine and Greek-Syrian decorative elements. It contains the head of Saint Anastasius the Persian, who suffered a martyr's death in 628 and whose relic was already mentioned in the 11th-century relic inventory of the Aachen Collegiate Church. In earlier times, the reliquary of Anastasius was attached atop the Shrine of St. Felix. HL

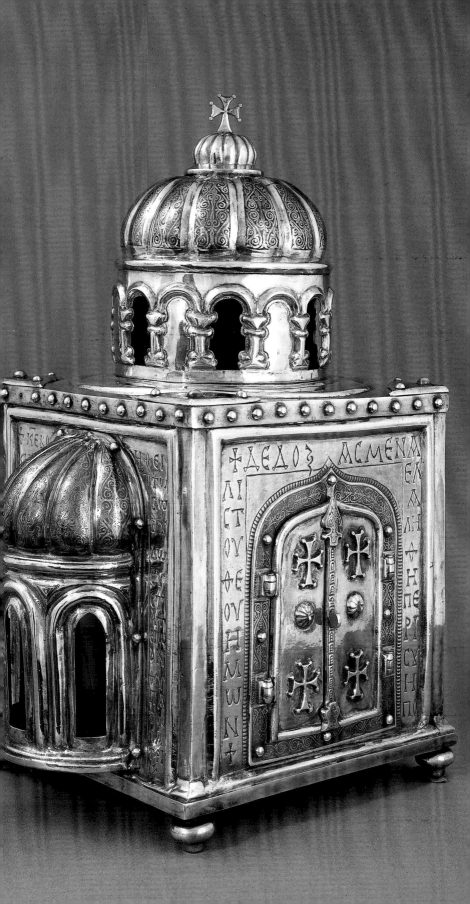

The Three Small Holy Relics

In terms of their significance, the three small relics closely follow the relics contained in the Shrine of the Virgin and like them, serve as a reminder of the earthly lives of Christ and His mother, the Virgin Mary. During the pilgrimages, they are placed on display in the Cathedral for veneration and like the Shrine of the Virgin Mary, are a destination for pilgrims.
 The reliquaries comprise a group of implements which were probably made in a goldsmith's workshop in Prague. The relics were kept within containers made from polished rock crystal. The purity and clarity of rock crystal symbolized Christ. As a result, it was the preferred material to protectively house the relics while at the same time, allowing them to be seen. Although no official proof exists, Emperor Charles IV was probably the commissioner of the reliquaries.

HL

Reliquary for the Flagellation Rope of Christ

- Prague (?), about 1380
- Rock crystal vessel; hammered silver, cast, gilt, antique and medieval precious stones, pearls, precious stones
- H. 54 cm, base diameter 21 cm

The rock crystal container is encased within the Late Gothic architecture of the reliquary. Its base is decorated with three medieval gems as well as another from Antiquity. In place of a node, the shaft displays a chapel-like structure with a form adapted from large-scale architecture. The vessel made of rock crystal is flanked by soaring columns that support the dome and a two-storied, tower-like baldachin. Within this canopy, a small figure of Jesus at the flagellation pole points to the flagellation rope. Pearls and precious stones embellish the sumptuous reliquary. Various architectural details of the reliquary speak in favor of its origin from a goldsmith in Prague, which in terms of large-scale architecture, resembles the chapels of St. Wenceslas and St. Andrew of the St. Vitus Cathedral. Likewise, the funnel-shaped gem settings reveal parallels to those of the Crown of Charles IV upon the Aachen Bust of Charlemagne.

HL

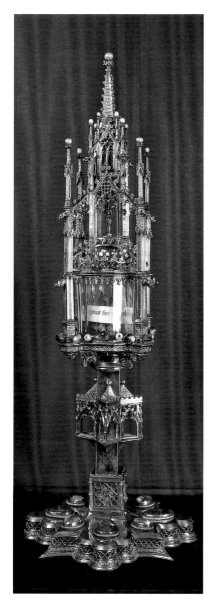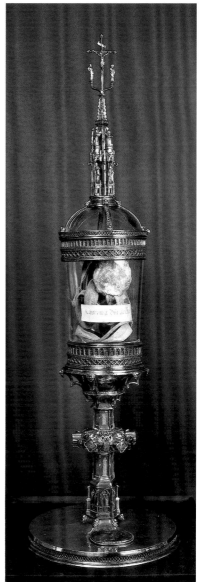

Reliquary for the Belt of Christ

- Prague (?), about 1370/80
- Rock crystal container with lid, hammered silver, cast, gilt, precious stones, one antique sardonyx with two male portraits, one antique carved onyx with female bust
- H. 69.5 cm, base diameter 22.5 cm
- Restored in 1870

This reliquary is the clearest and simplest of the group. Tradition maintains that it houses the leather belt of Christ. The relic, its seal, and its inscription are clearly visible through the rock crystal. The seal displays a male bust portrait with the attire of a Greek priest.

Arising from the flat, plate-shaped base adorned with two gemstones is a shaft composed of Gothic architectural elements. The shaft supports the vessel. Both the vessel and its lid are secured by slender tracery bands. The tower above the dome displays four martyrs and above them on a second level, four music-making angels. The Crucifixion scene is placed above the spire. The form of the glass component is closely related to secular Burgundian forms.

HL

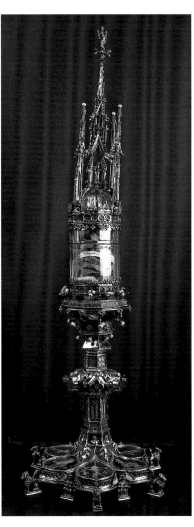

Reliquary for the Belt of the Virgin Mary

- Prague (?), about1360
- Rock crystal vessel with added glass lid, hammered, cast, gilt silver, translucent enamel, pearls, Gothic carved stones, one French agate cameo
- H. 62.5 cm, base diameter 21 cm

The slender polished rock crystal cylinder contains a braided linen belt of the Virgin Mary. The inscription upon the scroll reads: Zingulum B. Mariae Virginis. The reliquary is richly endowed with decorative figures. Six lions and six music-making angels are at the base; in translucent enamel at the base is the Crucifixion group with John the Evangelist, Peter, the Virgin, Paul, and Mary Magdalene; at the base of the dome above the crystal cylinder are four music making angels; within the tower are Saints Peter, Paul, Apollonia, and the Virgin Mary. Another image of the Virgin Mary crowns the reliquary. The funnel-shaped setting of the stones and pearls correspond to the Bohemian Crown of Charles IV, which was likely made in Prague and now crowns the Bust of Charlemagne. HL

Simeon Reliquary

- Aachen, around 1330/1340
- Hammered and gilt silver, pearls and stone cuttings, translucent enamel
- H. 37.9 cm, L. 59.6v, D. 14.6 cm

The relic case is thought to be older than the figures. Among the relics contained within it is an inscription from the 12th century. In a departure from the speaking reliquary, which was typical of the Middle Ages and whose shape indicated the type of relic kept inside, this reliquary calls Saint Simeon to mind by assuming the form of an altar resting upon four columns, upon which Christ was sacrificed. The scene of Jesus in the Temple is represented here. The Virgin Mary holds two sacrificial doves in her hands and fully extends her arms towards the Child, who is carried by the covered hands of the ancient Simeon. The base plate is covered with precious stones, while the altar is adorned with enamel, precious stones and gems. On the altar table, two enamel plates display the Virgin with Child and Charlemagne, who presents the pair with a small relic box. A similar depiction is located upon the dedication relief of the Shrine of Charlemagne. Between the two enamel plates upon the altar is a small, vase-shaped agate phial, which suggests an older, probably Byzantine, context. Two medallions, which are enclosed beneath glass, contain Gothic parchment inscriptions with the inventory of various saint relics contained inside the reliquary. From a stylistic point of view, the figure of the Virgin Mary can be assigned to the circle of donor-commissioned Madonnas from the Aachen Cathedral Treasury, while the figure of the ancient Simeon has its precedents in North French cathedral sculpture from about 1230.

HL

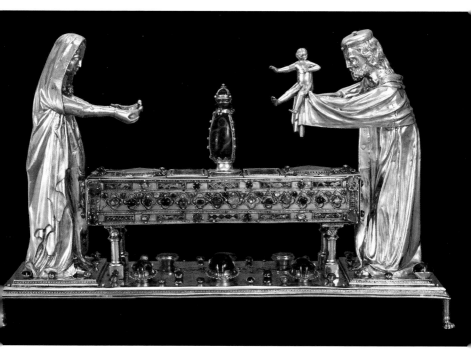

Disk Reliquary, Flabellum

- Around 1340/50
- Silver, hammered, engraved, embossed, gilt, translucent enamel, pearls, rock crystal capsules and precious stones
- H. 52 cm, W. 32 cm
- The champlevé plate at the reliquary shaft with the representation of Justice is from about 1160/1170 from the Meuse region. It probably originated from the shrine case of the Simeon reliquary.
- The angel figures from the latter half of the 14th century are probably from the workshop which made the Reliquary of Charlemagne. The wings have been renewed.

The disc-shaped reliquary consisting of gold work is developed from the form of the liturgical fan, or flabellum. The center of the disc forms a cross. Four relics are contained within small rock crystal capsules upon its uniformly even beams. The Gothic inscription describes them. The main relic, a part of the sponge which was soaked and given to Christ on the cross, is seen within a large crystal medallion at the intersection of the cross beams. Four enameled round medallions display scenes from the Passion and Resurrection of Christ. The frame of the reliquary is composed of 16 ornamental fields. At the height of the cross beams, the Four Evangelists are displayed, while the remaining areas feature ornamental foliage, filigree work, pearls, emeralds, and topaz stones.

The reverse of the hammered silver disc displays a cross which culminates in decorative art of the Agnus Dei and the Four Evangelist symbols. Its sequence corresponds to the symbols on the front side. The two flanking angels were once vessels used for pouring. The letters A and V, which appear upon their bases, indicate that these vessels were used for storing water (aqua) and wine (vinum). Most likely, they came from the workshop of the Reliquary of Charlemagne and correspond to the tradition of French examples. Comparable are the enamel pedestals of the Virgin and Child of Jeanne d´Evreux, between 1324 and 1339 in the Louvre, Paris.

HL

Crucifixion Altar, so-called Wenceslaus Altar or Bohemian Altar

- Aachen, before 1457
- Oil on oak
- H. 153 cm, middle panel W. 163 cm, wing W. 81.5 cm

The central panel of the winged altar shows the crucified, dead Christ upon a grassy area in front of a gold background. Beneath the cross, the mourning figures of Mary and John stand on either side of Christ. Along the sides are the patron saints of Bohemia. From the viewer's left is Saint Wenceslaus, in golden armor, ducal hat, imperial shield, and lancet with imperial banner; on the right is Saint Vitus with an orb. The kneeling emperor with fur-lined cloak and half-arch crown endorsed by Wenceslaus is thought to be Emperor Charles IV, while the king endorsed by Vitus may be King Ladislaus the Posthumous (based on images of the same period). Their coats of arms, which cannot be clearly assigned

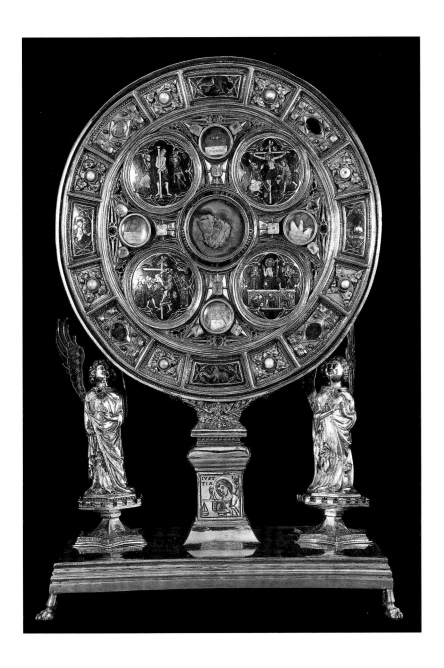

to either figure in particular, are displayed before the figures.

King Sigismund and Saint Ludmilla are represented in the left inner wing, and the holy Bishop Adalbert of Prague and the holy abbot Prokopus are shown on the right.

The outer wing displays the Annunciation of the Virgin Mary; beneath it on the left are Saint Stephen and Charlemagne with a model of the Cathedral; on the left are Saint Wenceslaus with the kneeling donor of the altarpiece, possibly the canon Sigismund of Iglau.

The altarpiece formed the retable of the Wenceslaus Altar (so-called Bohemian Altar) in the Aachen Cathedral. It was donated by Emperor Charles IV in 1362

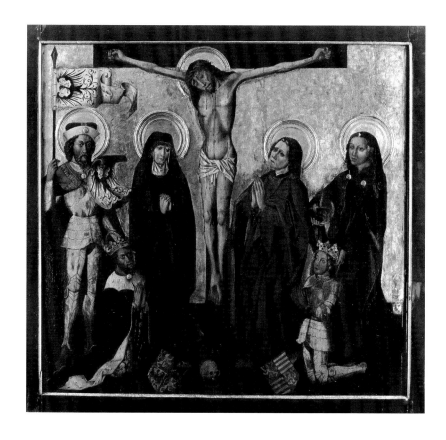

to the Bohemian pilgrims of Aachen. In 1455, Ladislaus the Posthumous, King of Bohemia and Hungary from 1453-1457, presented Sigismund of Iglau, canon in Alt-Buzlau, as the new prebendary of the altar, who then took responsibility for the Bohemian pilgrims. This could have been the reason for the commission of the altarpiece by Sigismund of Iglau.

The altar, which has since been largely painted over in modern colours, may have been executed by a painter from Aachen who was trained in Cologne. The portrayal of the room in the Annunciation has a correlation in the Cologne Ursula Cycle of the so-called Master of Cologne, from 1456.

GM

Textiles

With several thousand textiles, the Aachen Cathedral's Textile Treasury is among the richest of its kind. At the very center of attention are the textile relics. Of these, a number of them, which are referred to as major relics, are still especially venerated during the pilgrimage to Aachen. The covers which once decorated and protected these relics are world-renowned, Oriental and Byzantine silks from the 6th to the 10th centuries. Of particular beauty are the richly-adorned coverings of the major relics, which were made in 1629 and are still in use today. Additionally, the Textile Treasury includes all such textiles ranging from vestments for the Mass and altar cloths, to flags, rugs, wall carpets, and canopies, up to the vestments of the ones referred to as devotional images, to textile accouterments of the Cathedral belonging to the past and present and which bear witness to the beauty of the liturgy.

Among the realm of liturgical vestments, medieval examples, from the chasuble of Bernard to the so-called Cappa Leonis, are among the medieval gems of the Treasury; indeed, the collection of Baroque paraments is the largest in the Rhineland region. Due to conservation- and preservation-related concerns as well as limitations of space, the entire collection of textiles cannot be exhibited on a permanent basis.

Blue Chasuble, so-called Chasuble of St. Bernard

- Aachen (?), 2nd half of the 12th century
- Dark blue and yellow silk, pearl embroidery, gold trim
- The chasuble material was renewed in the Baroque style, with the shoulder section and lining repaired in 1968

The so-called Chasuble of St. Bernard is the oldest surviving liturgical vestment of the Aachen Cathedral. Only the collar trim and pearl embroidery of the original robe have survived. However, the cut of the cloth and the sequence of pearl embroidery appear to have retained the form of the Roman, bell-shaped chasuble versus the Gothic chasuble in which the sides were cut, in order to avoid gathering the material over the arms.

This chasuble is the oldest-known Mass vestment with real pearl edging. The pearl is a Biblical emblem for the riches of Heaven. The branch and leaf ornamentation of the bifurcated cross alludes to the Tree of Life and to the redemptive nature of the Eucharistic sacrifice.

The embroidered pearl ornamentation, consisting of four symmetrically opposed leaf tendrils and heart motifs sur-

rounded by tendrils, has direct parallels to two foundation plates of the Barbarossa Chandelier that was made in Aachen in 1165. The decoration is also closely related to an ornamental frieze of the arm reliquary of Charlemagne in Paris. Based upon this information, the chasuble may have been made in the second half of the 12th century in Aachen, possibly in connection to the canonization of Charlemagne in 1165.

According to the eponymous legend, Bernard of Clairvaux supposedly wore the magnificent chasuble in as early as 1147, at his call to the Crusades in Aachen. The legend may have taken root based upon the Marian symbolism of the pearls and the color blue. In the viewer's imagination, the chasuble thus corresponds to Bernard's devotion to the Virgin Mary.

GM

Choir Robe, so-called Cappa Leonis

- Cologne (edging); Italy, 14th century (silk velvet); about 1414 (silk lining); 1414 or 1520 (beams)
- Silk velvet, silk, gold and silver thread, gilt silver rosettes, 100 silver bells without clappers, pearls, precious stones
- L. 143 cm

The coronation robe, which since 1804 had been erroneously referred to as a choir robe after the legendary consecrator of the Aachen Cathedral, Pope Leo III, is one of the most valuable textiles of the Aachen Cathedral Treasury. The lower border from Cologne with flowers, stars, and prophets as well as 100 silver newly-corded silver bells running through it, comes from the 14th century. Its destroyed scroll may have referred to the sacred honor of the royal command. All areas of the unusual, once dark-red woven silk velvet are outlined in gold thread and embroidered with six-petaled knobbed rosettes with yellow centers. The front seam of the robe, as well as the small, hood-like shield on the back was decorated with unique beams at the beginning of the 15th century or perhaps only in the 16th century. An embroidered and braided

branch with foliage upon a gold background here was once studded with countless pearls. Upon the branches, sculptural, crocheted parrots have been attached.

The leaves and branches are surrounded by quatrefoils, which alternately contain silver-gilt, jeweled, and pearl-encrusted rosettes, as well as faded and thus unidentifiable coats of arms, and empty areas which carry traces of an appliquéd metal.

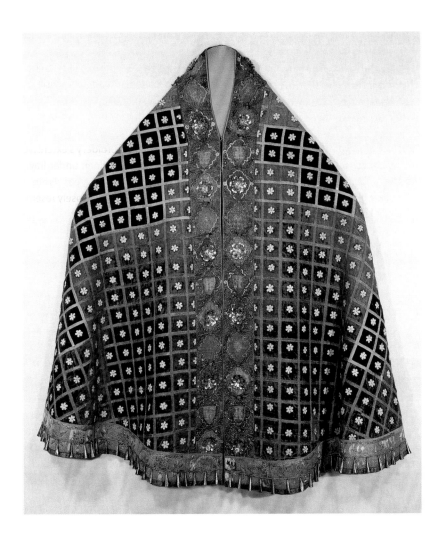

The cream-colored silk lining of the robe, an Italian silk from approximately 1414, features a vine leaf pattern with grapes and leaping stags.

Most likely, the choir robe served as the coronation robe at the coronations of Charles IV in 1349, Sigismund in 1414, and most certainly, Charles V in 1520, each time with a different appearance.

GM

Madonna as Protector

- Brussels (?) before 1473
- Gold and silver thread, as well as silk embroidery on linen
- H. 57 cm, W. 71 cm

The Mother of God stand dominates the image, standing upon a tile floor with the infant Christ on her arm. Beneath the cloak which is supported by two angels, kneel pilgrims from all walks of life dressed in contemporary attire. They seek refuge in the protection of the Mother of God, as the "mater omnium." The pilgrims are led by a pair of donors, dressed in royal attire and shown in an individual, portrait-like manner. They are probably Charles the Bold and his spouse Margaret of York. The Madonna as Protector, whose original purpose re-

mains unexplained, may have been donated to commemorate the visit of Charles the Bold in Aachen in 1473. (For comparison, refer to the Crown of Margaret of York.)

As a result of the embroidery's extensive damage, the splendid linen underdrawings are visible in many areas. From a stylistic perspective, they closely resemble Jan van Eyck's Madonna in the Church in Berlin. The Aachen Madonna as Protector is also closely connected to a middle section of the first pulpit hanging, made at the same time for the Order of the Golden Fleece in Vienna, as well as to another contemporary altarpiece (Claude de Villa) which was made and is on display in Brussel.

GM

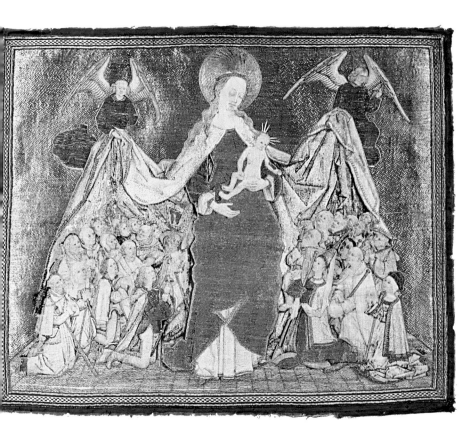

Bibliography

Bock, F., Der Reliquienschatz des Liebfrauen-Münsters zu Aachen, Aachen 1860

Bock, F., Karls des Großen Pfalzkapelle und ihre Schätze, Cöln und Neuß 1865

Brandt, M., Die Macht des Silbers. Karolingische Schätze im Norden, Frankfurt, Hildesheim 2005

Christ, W./Minkenberg, G., Gemälde und Skulpturen des Aachener Domes im Blickfeld von Konservierung und Restaurierung, Aachen 1995

Domkapitel Aachen (Publisher), Der Schrein Karls des Großen, Aachen 1998

Effenberger, A./Drescher, H., Pinienzapfen, in: Katalog Bernward von Hildesheim und das Zeitalter der Ottonen II, Hildesheim 1993

Faymonville, K., Die Kunstdenkmäler der Rhineprovinz, Aachen I., Das Münster, Düsseldorf 1916

Fränkische Reichsannalen, in: Quellen zur karolingischen Reichsgeschichte I, Freiherr vom Stein-Gedächtnisausgabe, Band V, Darmstadt 1955

Fritz, J.-M., Goldschmiedekunst der Gotik in Mitteleuropa, München 1982

Giersiepen, H., Die Inschriften des Aachener Doms, Wiesbaden 1992

Grimme, E. L'orsa G., Der Aachener Domschatz, Aachener Kunstblätter, Vol. 42, Aachen 1972 (with a description of all objects and an older bibliography)

Grimme, E. L' orsa G., Der Dom zu Aachen. Architektur und Ausstattung, Aachen 1994

Jülich, Th., Die ungarischen Kelche der Aachener Domschatzkammer, in: CELICA IHERUSALEM, Festschrift für Erich Stephany, Köln-Siegburg 1986

Karlsverein-Dombauverein, Schriftenreihe, Vol. 4, Aachen 2001, Lepie, H., Schimmernd in lauterem Gold … und leuchtend von kostbaren Steinen

Karlsverein-Dombauverein, Schriftenreihe, Vol. 5, Aachen 2002, Lepie, H./Schmitt, L./Röthinger, R., Pala d'Oro, Restaurierungsberichte

Karlsverein-Dombauverein, Schriftenreihe, Vol. 8, Aachen 2006, Schein, K./Wentzler, R., Hoffnung und Gewissheit, Aachens Dom und Domschatz in Kriegs- und Nachkriegszeit

Kessel, J.-H., Geschichtliche Mitteilungen über die Heiligthümer der Stiftskirche zu Aachen, Köln und Neuß 1874

Lehmann, T., Überlegungen zur Bestattung im spätantiken Kirchenbau, in: Der basilikale Komplex in Cimitile, Oberhausen 2007

Lepie, H./Minkenberg, G., Die Schatzkammer des Aachener Domes, Aachen 1995

Lepie, H./Schmitt, L., Der Barbarossaleuchter im Dom zu Aachen, Aachen 1998

Lepie, H./Münchow, A., Elfenbeinkunst aus dem Aachener Domschatz, Petersberg 2006

Minkenberg, G., Der Barbarossaleuchter im Dom zu Aachen, in: Zeitschrift des Aachener Geschichtsvereins 96, Aachen 1989

Minkenberg, G., Die vier großen Heiligtümer und ihre textilen Hüllen, in: Wynands (Publisher), Der Aachener Marienschrein. Eine Festschrift, Aachen 2000

Münchow, A./Lepie, H., Pala d'Oro, Köln 1996

Nesselrath, A., L'orsa o cosidetta „Lupa", in: Katalog Carlo Magno a Roma, Rom 2000

Tietzel, B., Geschichte der Webkunst. Technische Grundlagen und künstlerische Traditionen, Ostfildern 1991

Urbanek, R./Henkelmann, V., Salve Regina. Zur Strahlenkranzmadonna des Jan von Steffeswert im Aachener Dom, Aachen 1998

Urbanek, R., Transparent. Untersuchungen zum Retabel des Böhmenaltars, Aachen 2004

Wynands, D. (Publisher), Der Aachener Marienschrein, Eine Festschrift, Aachen 2000